6 ARTISTS PAINT A LANDSCAPE

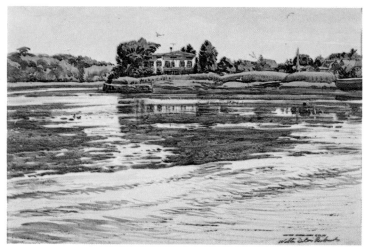

WALTER DU BOIS RICHARDS

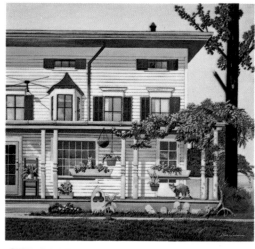

STEVAN DOHANOS

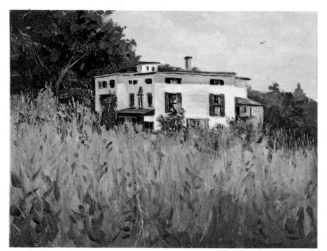

JOHN PELLEW

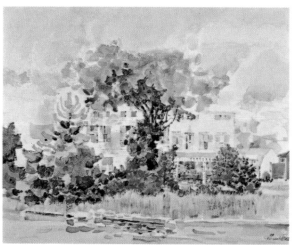

ALEXANDER ROSS

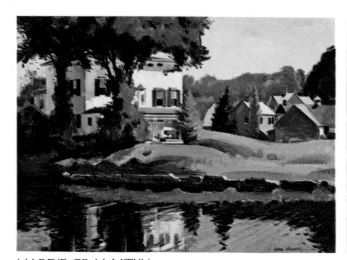

HARDIE GRAMATKY

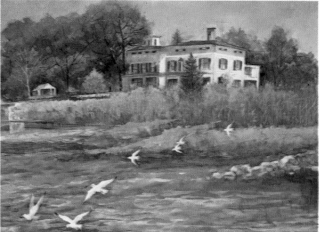

HANS WALLEEN

EDITED BY CHARLES M. DAUGHERTY

6 ARTISTS PAINT A LANDSCAPE

WALTER DU BOIS RICHARDS
STEVAN DOHANOS
HARDIE GRAMATKY
JOHN PELLEW
HANS WALLEEN
ALEXANDER ROSS

PUBLISHED BY NORTH LIGHT PUBLISHERS
WESTPORT, CONN.

DISTRIBUTED BY WATSON-GUPTILL PUBLICATIONS
NEW YORK

Dft - 9/86

Published by NORTH LIGHT PUBLISHERS, a division of
FLETCHER ART SERVICES, INC., 37 Franklin Street,
Westport, Conn. 06880.

Distributed by WATSON-GUPTILL PUBLICATIONS, a
division of BILLBOARD PUBLICATIONS, Inc.,
1 Astor Plaza, N.Y.C., N.Y. 10036.

Manufactured in U.S.A.
First Printing 1975

Library of Congress Cataloging in Publication Data

Main entry under title:

6 artists paint a landscape.

 1. Landscape painting — Technique. I. Daugherty,
Charles Michael.
ND1342.S58 751'.4 75-11511
ISBN 0-89134-002-5

Library of Congress Catalog Card Number 75-11511
ISBN 0-89134-002-5 & 0-8230-4850-0.
Designed by Geoffrey Reed
Composed in ten point Helvetica by John W. Shields, Inc.
Printed and bound by Kingsport Press.

CONTENTS

INTRODUCTION

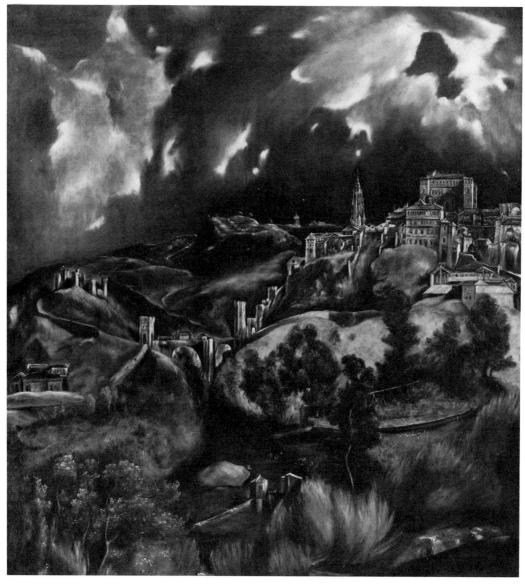

VIEW OF TOLEDO
El Greco (1541-1614)
The Metropolitan Museum of Art
Bequest of Mrs. H. O. Havemeyer, 1929.
The H. O. Havemeyer Collection

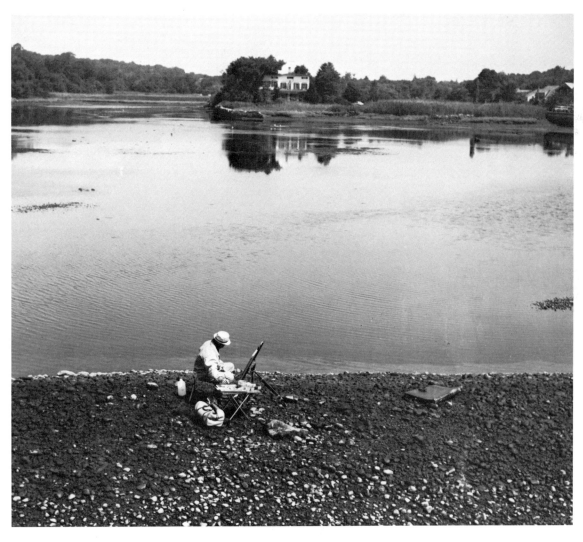

What interests me are the shapes and reflections made by the tidal flats and pools in the foreground.

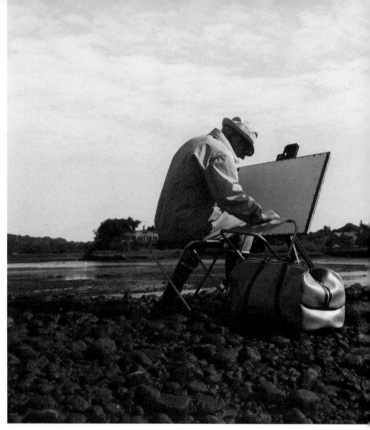

I visited the site several times and studied it under different lighting conditions before choosing a place from which to work.

I carry two folding stools: one to sit on and the other to use as a table.

Paint box, brushes, water, sponges — everything I need is conveniently at hand.

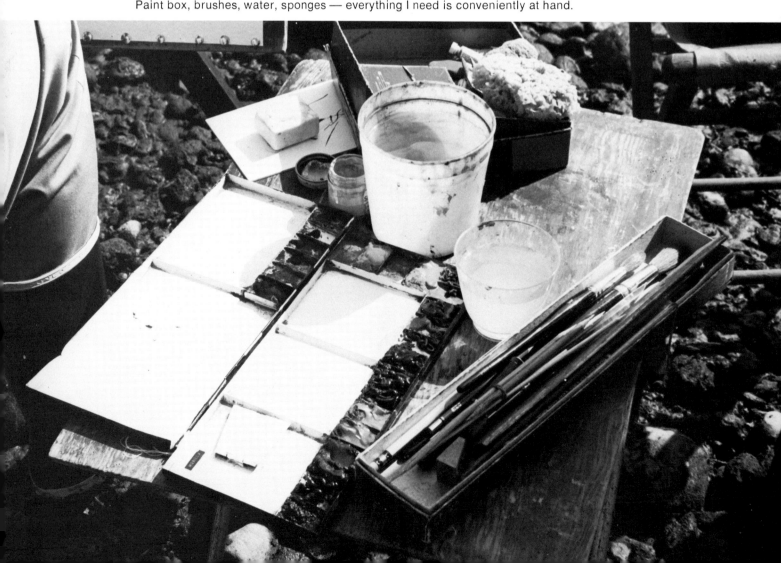

Walter DuBois Richards is an artist whose forthright purpose is to record what he sees the way he sees it. He works in watercolor and lithography and finds his preferred subjects out of doors. His land and seascapes are often realized in expansive panoramas, as though he saw with sharp focus, wide-angle vision. They contain a sense of space and air, in which the solid forms of place and things are indicated with thoughtful attention to detail.

His work has been exhibited at the Metropolitan Museum of Art, the Pennsylvania Academy of Fine Arts, The Art Institute of Chicago, the Whitney Museum of American Art and many other museums and galleries. He has executed commissions for some of America's largest industries and foremost publications, including Life, Look, Collier's and Reader's Digest. A variety of assignments, particularly as Official Historian Painter for the United States Air Force, have taken him to South America, Europe and Asia.

He is the winner of many awards for lithography and watercolor. A member of the American Watercolor Society, he has served that organization as recording secretary (1960 and 61) and vice-president (1962 to 1970). He belongs also to the National Academy of Design, the Society of Illustrators and the Connecticut Watercolor Society. He is the founder and current president of the Fairfield Watercolor group.

In this demonstration Walter Richards shows and describes, much as he does in the popular watercolor classes that he conducts from his New Canaan, Connecticut studio, how he goes about painting a landscape.

"I visited the location three or four times and studied it quite a bit before getting ready to begin painting — trying to figure just where the best viewing point is and what kind of light I'd like to work under. The thing that excites me about this subject is all the interesting shapes and reflections made by the mud flats and tidal pools in front of the old white house at low tide. There's something symbolic about the house and the very primeval tidal flats. And then there's the expanse of sky, the small green island, and the sunlight striking the house and making it a brilliant white accent in the middle distance.

"Getting set up properly is an important part of the technique of sketching outdoors. This means having all the equipment you'll need handy and making yourself as comfortable as possible.

"Before I go out I get my things together— paints, brushes, a jar of water, a pocket knife and so forth—and pack them in an ordinary satchel. The paper I'm going to work on is tacked to a large drawing board. For this job I'm using a two hundred and forty pound German watercolor paper. It has only a moderately rough surface as water-color papers go. I've had fairly good luck with it the two or three times I've used it; I think the paintings were interesting and the washes had a glow. So I decided I'd keep going with it. It's important to use a good quality paper for working in watercolor.

"I carry two folding stools — one to sit on and the other to use as a table for my palette and other equipment. My paints are good quality tube pigments. The best brushes for watercolor are sables. I use a large round sable, about a number fourteen, for the

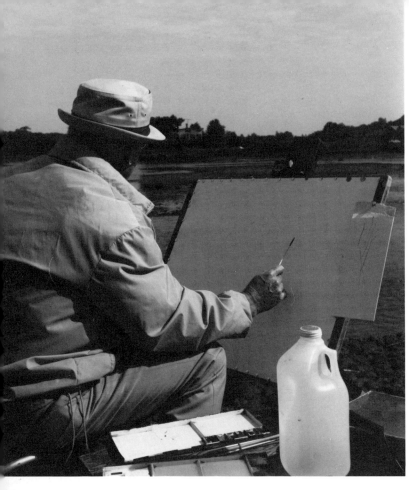

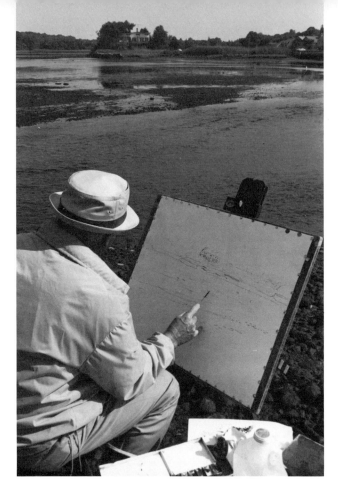

The watercolor paper is securely tacked to a large drawing board. A second sheet on the other side is in reserve in case I should have to make a second beginning.

The preliminary drawing is made with a pointed stick dipped in India ink.

principal washes and a few smaller ones for the more intricate areas. I carry one oil bristle brush to use when I want to scrub out an area.

"I also carry the drawing board, with the paper tacked to it, in a large portfolio. As an alternative, in case anything should go wrong or I have to begin over again for any reason, I tack another piece of watercolor paper on the back of the board. The second piece, in this instance, is Royal Watercolor Society paper.

"Before going any further I have found it a good precaution to take a color shot of the scene with my camera. I'll often snap a couple more as the work progresses, especially if the sky keeps making interesting changes. This is always a good safety measure in case it clouds up heavily, or if for any reason I don't get finished and can't come back to the painting site. Ninety-eight percent of the time I won't even refer to the photos, but they give me a record in case

I have to complete the job in my studio.

"As for the subject of my picture, I've always been interested in landscape and outdoor scenes and activities. I believe that I have a knack for getting the feeling of air in my pictures, which may not be very fashionable just now, but I just go ahead and do it my own way. No matter what I try to do it's going to look like I did it anyway. I like strong patterns as a rule and I like dramatic subjects.

"It all looks at its best to me in the early morning light. So I have to wait for a day when the tide is low at the time of day I want to work. Then I'm able to walk right out in the river bed and set up on a stony bar that stays high and dry for a couple of hours just before and after slack ebb tide.

"After my paper is on the easel and everything's set up, comes the drawing. For this I have a somewhat unusual technique.

14

I draw with a pointed stick that I dip in India ink. You can buy sticks for this purpose in the art stores, but I go to the lumber yard and get ordinary dowels — the smallest they have: about the thickness of a pencil or even slimmer. I sharpen the ends with a pencil sharpener. In some respects I guess this would be considered an awkward tool, but the stick is kind of limber, and I like its light touch and the sensitive line I can get this way. I like to make myself some problems because from all my years of meeting deadlines and doing work on demand I've become very accurate and facile. These are good assets to have, of course, especially at three or four o'clock in the morning when you're getting tired, and the job's due at nine. But when I paint outdoors for my own pleasure and satisfaction, I want a little extra challenge and the excitement that

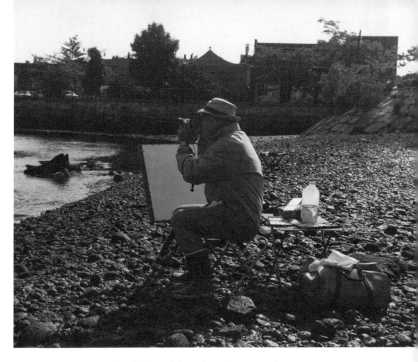

A color photograph of the subject for the record. I'll probably take several more if the sky gets interesting or the weather changes.

I keep the drawing light and simple. For a few dark accents I use a small brush.

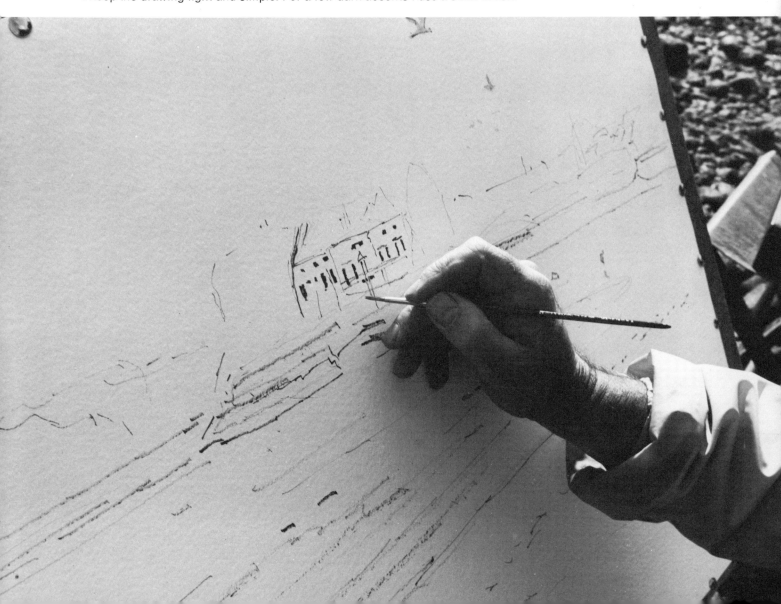

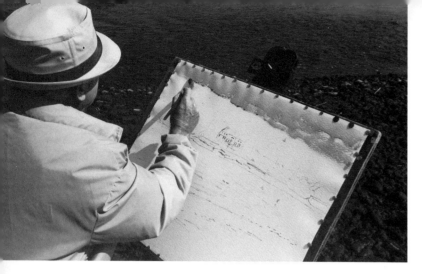

The sky wash is a mixture of cerulean and cobalt—

—with a little yellow gold added to warm it down toward the horizon.

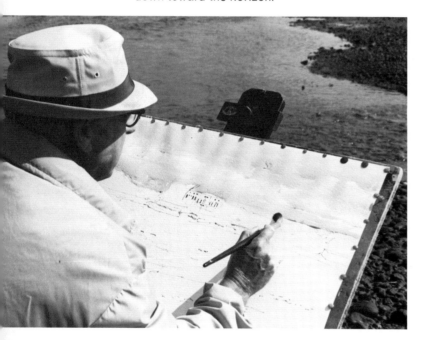

My old paint box is my palette. I've used it so much that it's falling apart but I still like it.

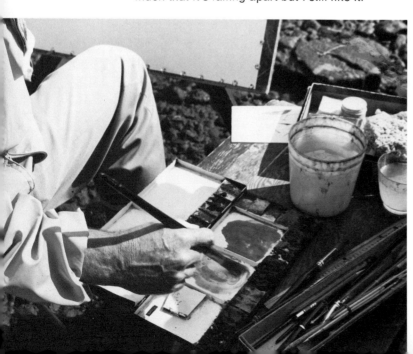

comes with a different approach. This can sometimes be had by using unconventional methods or tools, such as my drawing sticks.

"I would also say that I like to work this way because I'm a graphic artist who does a lot of lithographs and is accustomed to drawing on stone. An oil painter thinks in terms of masses and textures and the way he lays the paint on, whereas I think in more of a linear way. And, finally, drawing with the sticks is simply a quick and effective way to sketch.

"I tack a small piece of paper at one side of my drawing board for trying the point and getting myself loosened up. I keep the drawing light, except for a few little accents, and don't try to carry it too far. When I've established the eye level and indicated the general proportions of the important shapes in the picture, I'm ready to begin painting.

"At this point I open the bottle of water and lay out my palette. I've used my old paint box so much it's falling apart, but I still like it. I stress a limited palette. Generally I use a cadmium yellow. I also carry lemon yellow but don't use it often. My reds are vermillion and Indian red. Now and then I use alizarin crimson but not often because it's a fugitive color. I carry yellow ochre, raw sienna, burnt sienna, raw umber (which I use a lot) and burnt umber. My blues are cerulean, cobalt, ultramarine and sometimes Winsor blue. The only green on the palette is viridian. Once in a while I use Payne's gray.

"Equal parts of cadmium yellow, vermillion and raw umber make a very useful gold that I rely on a lot. I prepare a good supply of it and keep it on my palette at all times. When it runs out I mix some more. The way I use it, for the most part, is to mix with other colors to keep a unity in the painting. By changing the proportions a little I can make this gold more on the red side, or the yellow, a little lighter or a bit darker. Then I season my other colors with it. For example, I can gray a blue or, by going more to the yellow, make it a golden green. I can tone down a red or bring

it more to the orange side.

"Before beginning to paint I mask out a few small areas that I want to remain white in the finished picture. For this I usually use Maskoid, a liquid frisket material, but rubber cement will do the same thing. It's a good idea to use an old brush for painting it on because the stuff hardens quickly. A little soap on the brush will help keep it soft. The soap doesn't interfere with the Maskoid, but I use a separate container for the water in which I rinse the brush. Otherwise the Maskoid will float on top of the water and get in your good brushes and possibly spoil them.

"Now I paint the Maskoid over the white heron there on the tidal flat and on a seagull flying over and one or two other small places that are going to be pure white in the finished picture. (I don't use it on the large white areas because I can paint around them.) The Maskoid will stay there until the painting is finished. I run my washes right over it and it blocks out the paint from making contact with the paper. Then, in the end, when the paint is dry, I'll remove the Maskoid with a "pick up" rubber cement eraser and the white paper under it will be exposed.

"The first thing is the sky. I run the sky wash with my biggest brush. Generally, with watercolor, you work from light to dark. You can always darken by adding more washes but it's difficult to make a wash lighter after it has dried.

"The blue in my sky is a mixture of cerulean and cobalt. I mix the paint with enough water to make a fluid wash, but I don't work as wet as some watercolorists do. Perhaps this again is the influence of my experience as a graphic artist, where drawing is the important thing and the approach is linear.

"Near the horizon the sky is lighter and a bit warmer. Here's where I mix a little of my gold in with the blue to pull it toward the warm side. The pools of water in the river bed mirror the sky so a light wash of sky color goes in there.

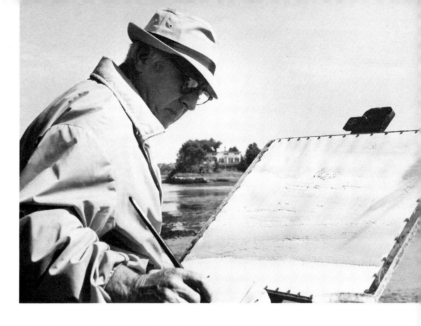

The river bed with its wet mud and pools of water reflects the sky so I cover it with a light wash of sky color.

As I begin working in the greens around the house I go to a smaller brush than I used for the big sky wash.

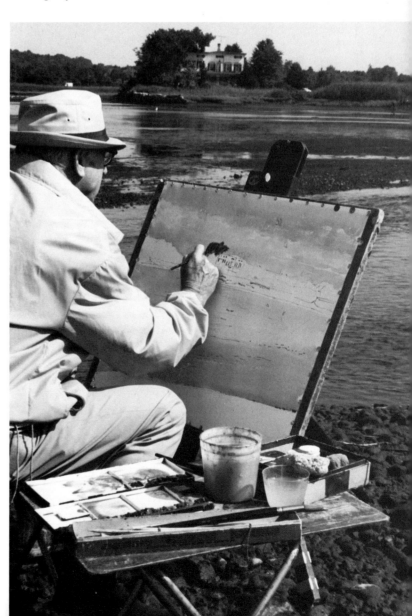

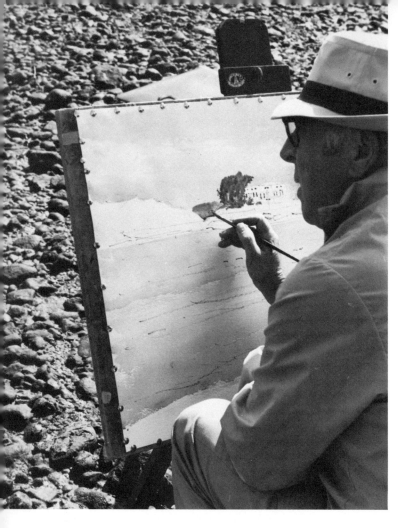

"Next is the band of greens that runs across the entire width of the paper. Here I work with a somewhat smaller brush. There's a good deal of variety in the greens of those trees and all the foliage surrounding the white house. I vary the values and shades of the green by mixing viridian with a little of my gold where I want it to go toward the warmer and yellower side, and with blue where it's cooler and perhaps darker.

"The house is not much more than a little white accent, framed by dark foliage. In painting it there's no need for being too specific with details. At the same time its whiteness and its position in the upper center of the picture, with the reflection coming down into the river, give it emphasis and help make it the definite focal center.

I put a little of my pre-mixed gold into nearly all the colors. It warms them and helps hold the painting together.

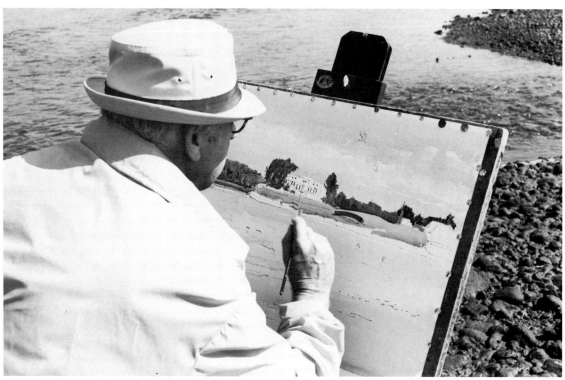

18

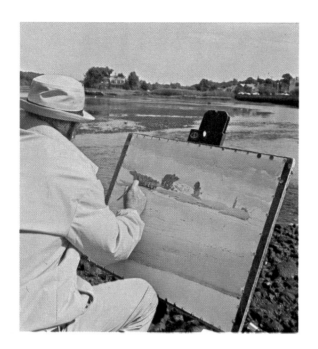 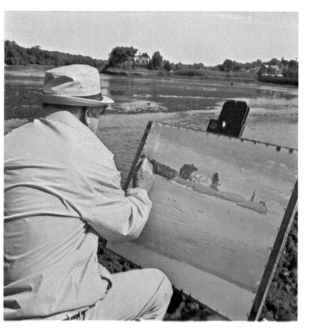

There's a good deal of variety in the greens. In the lighter, warmer areas I mix a generous amount of the gold with viridian. For the cooler, darker greens I mix in blue.

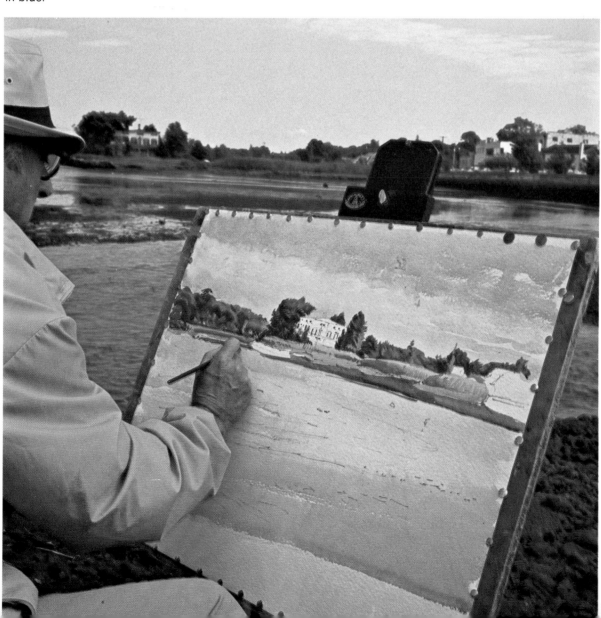

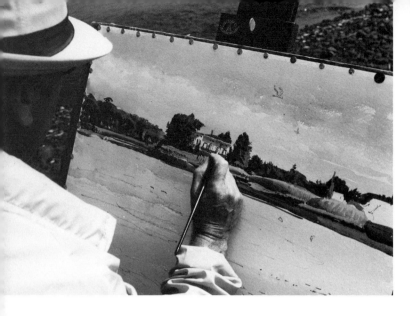

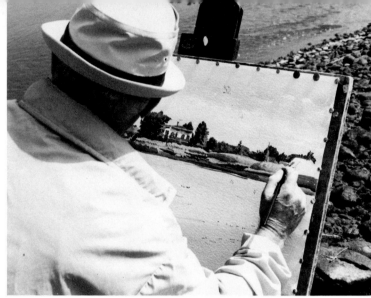

The architectural details can be suggested with a few judiciously placed brush strokes.

The strongest value contrasts are also reserved for the house. Those of other areas are minimized.

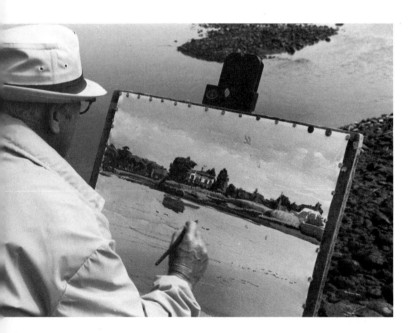

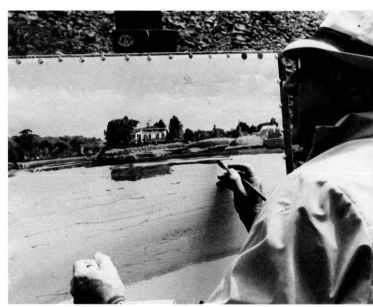

What interests me pictorially is the foreground area that occupies the larger part of the composition.

The land shapes are mirrored in the pools of shallow water.

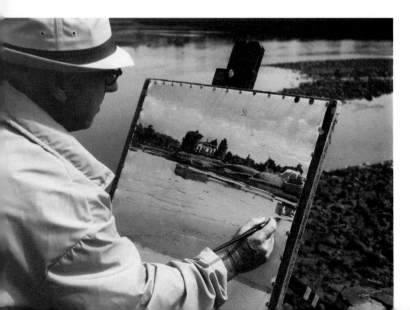

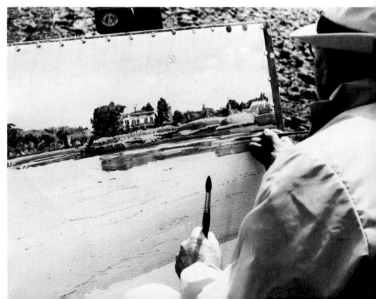

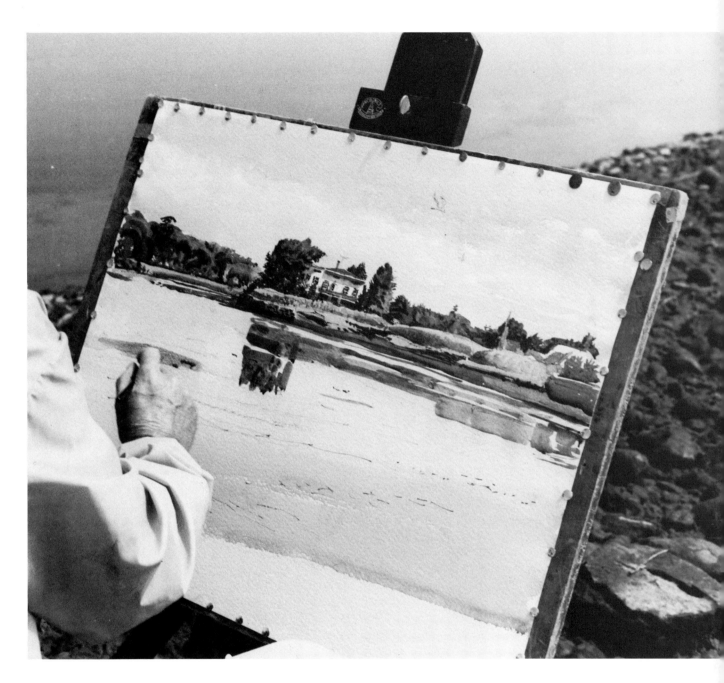

"The lower part of my paper is foreground—
the mud flats and tidal pools of the river bed.
This is the part that interests me most, with
its reflections and big patterns. As I work on
it, putting in the dark and middle tone washes
that represent the mud flats, I am nearing
the point where the picture will be finished.

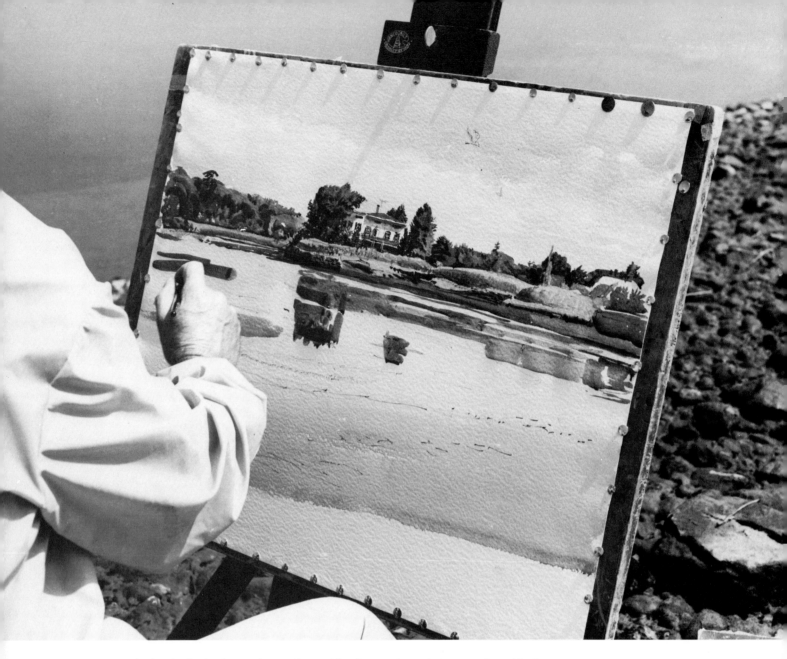

As I paint in the large shapes formed by the patches of stone and mud in the river bed an interesting pattern of lights and darks begins to develop.

But the tide is coming in. The sun's getting higher and the light is changing. I don't want to take a chance of ruining what I've already done. So I decide to call it a day and leave the crucial finishing touches for a second session.

"Usually I can do the entire job in one sitting. But since I didn't finish on this occasion, and it's almost impossible to find the light and the tide exactly the same a second time, I complete the painting in the studio.

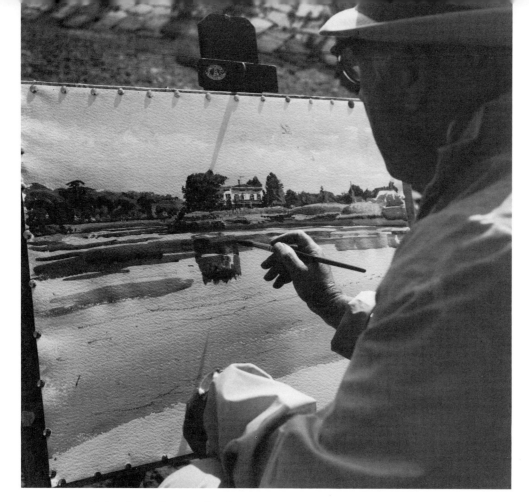

A few last minute reflection patterns are quickly indicated—

—then it's time to head home.

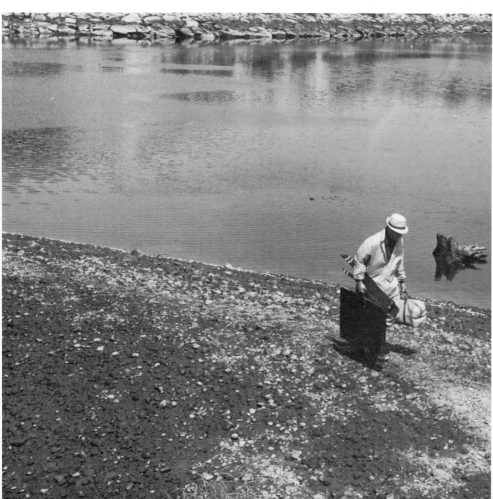

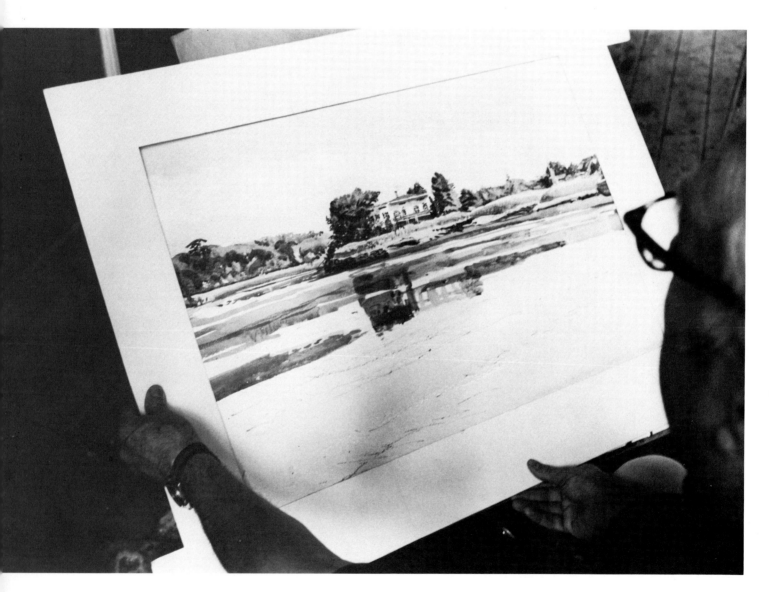

Framing the painting with a pair of L-shaped pieces of mat board helps me to decide on the best picture proportions.

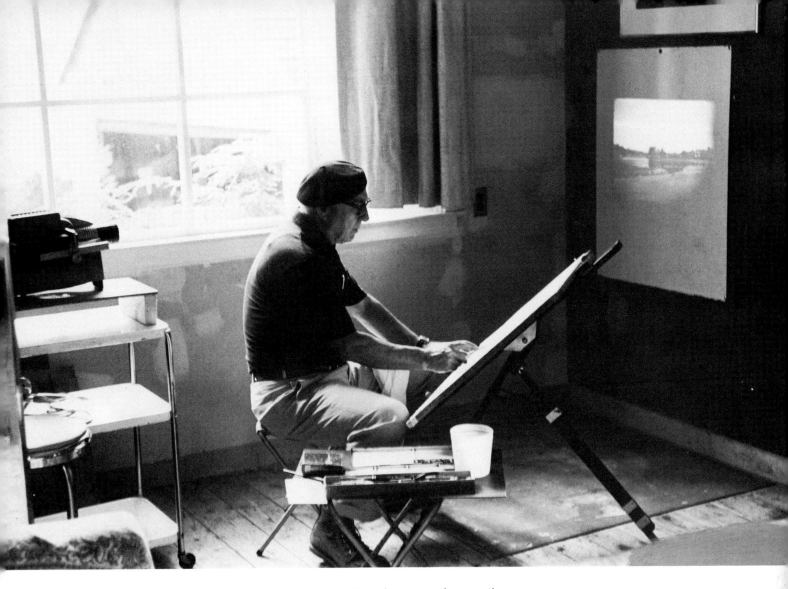

Projecting a color slide of the photograph I took on the scene gives me the information I need for revising and finishing.

"Here, with the painting on my work table, I study what I've done and consider just what I want to do further. Two L-shaped pieces of mat board enable me to mask parts of the painting and contemplate various possible arrangements of format. I find that there are probably four or five pictures here, depending on how I want to do it.

"Now the color photographs I took are useful. By projecting one on a screen or white wall, I have a reference to the scene just as it looked while I was painting it.

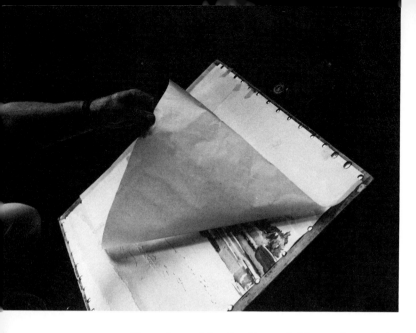
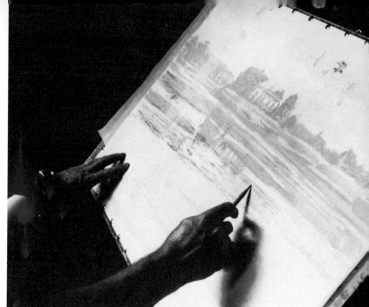

On a piece of tracing tissue, laid over the painting, I indicate with pencil the changes and additions I want to make.

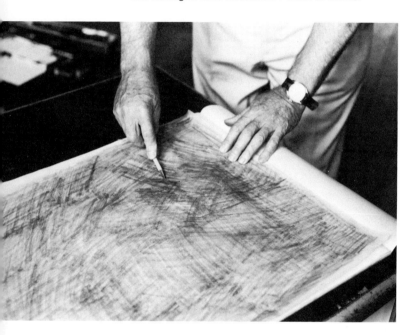
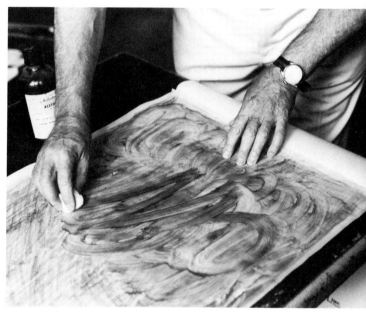

I prepare to transfer the changes onto the watercolor paper by covering the back of the tissue with an over-all tone made with the side of the pencil lead.

Rubbing with acetone on a wad of cotton distributes the pencil markings more or less evenly.

"I place a sheet of tracing paper over the watercolor and indicate with pencil the changes or additions I want to make in the patterns of the river bed. I play around with details — some birds and things. But I don't want it to get too busy and in the end I pretty much stay with the original concept.

"I make a tracing of the few modifications I want in the painting by pencilling one side of a second sheet of tissue with an all-over tone, thus turning it into a kind of carbon paper. I slip this sheet, pencil side down, between the top overlay and the painting. Now I simply trace whatever drawing changes I want from the overlay onto the watercolor paper. I remove both tissues and

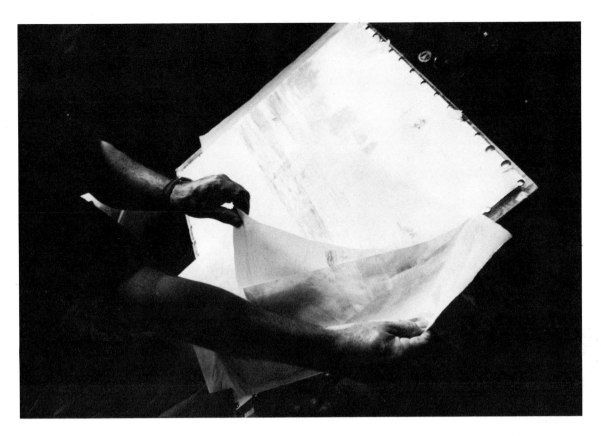

I slip the prepared tracing paper under the overlay drawing—

—and transfer the drawing to the surface of the painting.

The small white areas that were masked out in the beginning are now uncovered by erasing the Maskoid with a pick-up eraser.

The shapes of the gulls are refined and given three-dimensional form.

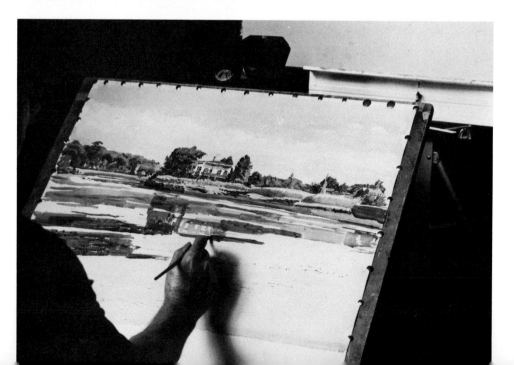

Creating the transparent effect of the shallow water was a real challenge. The suggestion of a stoney bottom through the water helped the illusion.

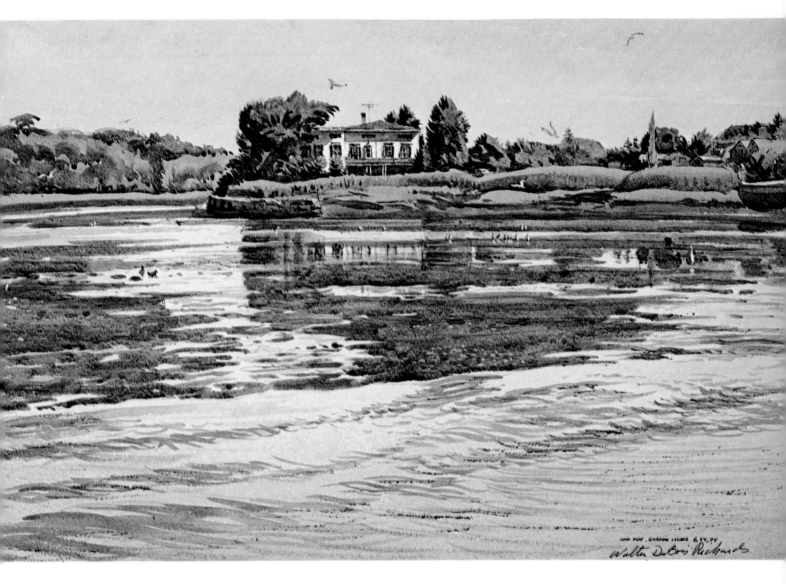

In framing the finished painting, I decided to crop the sky area further in order to make the foreground more prominent.

I'm ready for the last washes and final accents. Those little white spots that were masked out in the beginning are now uncovered by erasing the Maskoid and the shapes of the birds are refined.

"After painting in the adjustments traced from the overlay sheets, I further add the indications of rippling water across the foreground area and the picture is finished."

2 STEVAN DOHANOS

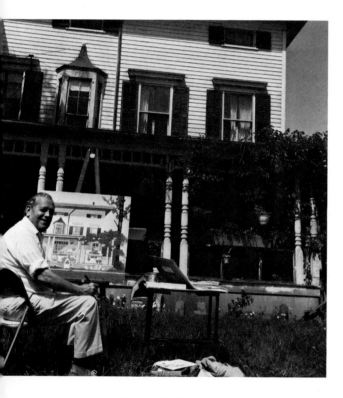

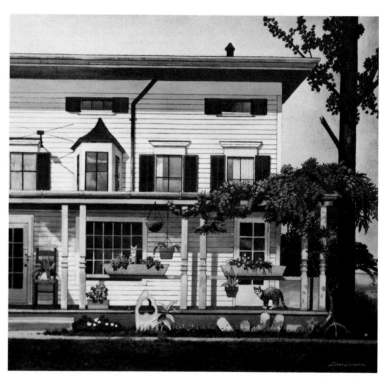

Stevan Dohanos' favorite landscapes are "housescapes."

This is the second painting I've done of the old house on Gorham Island.

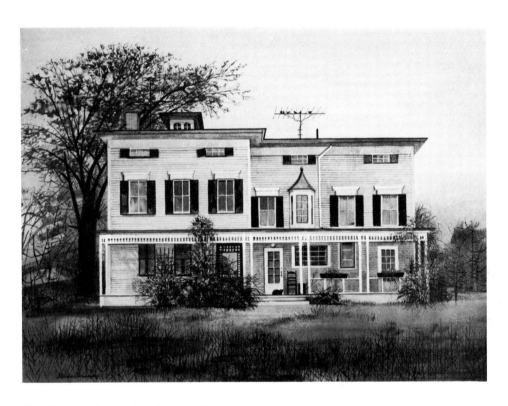

The first version, painted several years
previously.

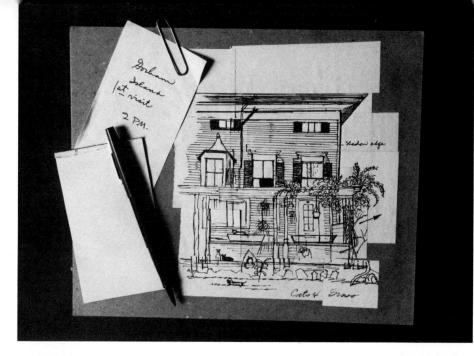

Initial sketch:
pen-and-ink on 3″x5″
sheets of paper,
pasted together.

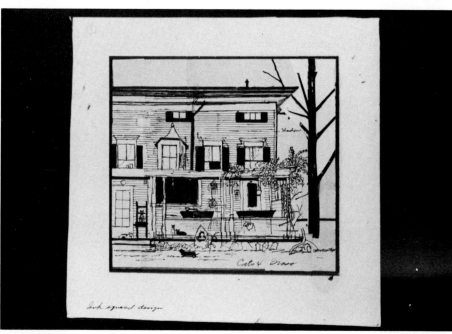

The ink square
drawing — with cats.

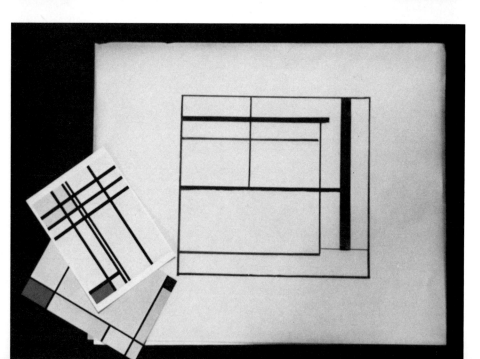

The importance I give
to the balance and
arrangement of
verticals and
horizontals indicates
a debt to Mondrian.

Stevan Dohanos' admiration for objects of common usage, particularly those that reflect the spirit of American enterprise at its homeliest and homeiest, is clearly evident in the affection and perfection with which he paints them. By integrating the functional lines and forms of these artifacts with his own graphic design, he creates pictures that can be viewed as two-layered structures of design within design.

When he looks at a landscape he focuses on the man-made objects in it. His favorite object is the house. He may joke about his "edifice complex" and quip, "Don't paint your house — I'll paint it," but his "housescapes" as he likes to call them, are more than mere façades. They simultaneously incorporate historical ichnography, gentle comment on the human drama, and thoughtful organization of space.

The ideas for many of the numerous cover paintings he has done for the Saturday Evening Post originated with choice architectural specimens, to which he added the appropriate personnel, situation or incident. Conversely, if the incident came first to mind, there was always an architectural setting to complete it.

In addition to being a popular and prolific cover artist and magazine illustrator, Stevan Dohanos has painted murals for Federal buildings in the United States and the Virgin Islands. He is presently chairman of the Postmaster General's Citizens Stamp Advisory Committee, and has himself designed 15 United States postage stamps. His paintings are in the collections of the Cleveland Museum, Whitney Museum of American Art, Pennsylvania Academy, Avery Memorial in Hartford, Connecticut, New Britain Museum of American Art and Dartmouth College. He is a past president of the Society of Illustrators.

All of which notwithstanding he still is, by his own definition, first and always a house painter, and herewith he demonstrates how he goes about it.

"The architecture of America — of our small towns and our cities — is changing rapidly and the artists of America are recording many of these changes. In this way artists are historians. By our interest in the old landmarks we're making a contribution toward preserving the architectural record of our country.

"The paintings of Edward Hopper and Charles Burchfield have been the principal inspiration in my own painting. I admire the way in which they project the individual personalities of the places they paint.

"As a beginning artist in Cleveland, I worked all week in a commercial art studio. But on Sundays I prowled around the back streets of the city searching for subjects that appealed to me — houses and buildings of all kinds — and painted them.

"During the past thirty-seven years, living in Westport, I've been doing the same thing — painting the town scene: the fire house, the school house, the town hall, residences, shop fronts, chicken coops, churches — all these and more have been the subjects of my paintings.

"Often I build some incident of human interest around a specific place and many of these have become Saturday Evening Post covers. Or sometimes it works the other way — I'll find the editorial idea, then seek out the right place in which to set it. Even on vacations I keep on the lookout for the architectural characters of places and I invariably end up with paintings of those that most appeal to me. As a variation on the term *landscapes* I call them *housescapes.*

"I've been observing the old house on Gorham Island for the last ten years. It appeals to me for several reasons. It was once a grand house — the type of place that was the pride of its neighborhood. An article in a recent issue of the Westport News says of it, 'Once a stately Victorian home built in 1860 on Main Street . . . the big house was sold a century later . . . and moved to Gorham Island.'

"During its long existence it evidently was added onto several times. There's no rhyme nor reason to some of the window arrangements. Artistically it's a happy confusion of shapes held together by a solid structure.

"Several years ago I felt compelled to make my first try at painting it. Probably I wouldn't have if it had just recently been given three coats of fresh paint. But in its neglected state I had a great sympathy for its paintable character. I purposely made the coloration as faithful to the original as possible, always picking up the patina of age which to me, as an American realist, is one of the exciting challenges in painting.

"I think of this picture as basically a Mondrian hiding behind an old building. I walked around, of course, as any artist does, trying to find the point of view that I considered to be unique and to have the best design possibilities. But somehow, as almost always, I ended up sitting right in front of it.

"I have a one point perspective and I'm proud of it. When I draw or paint a building I usually sit opposite the exact center of the façade, and I'm happy as a clam because the lines are all horizontal and vertical and I love that quality in a painting. It's in this respect that I owe a debt to Mondrian. I think

a lot of contemporary design also owes a debt to him for that horizontal-vertical concept.

"In living in a town or an area, an artist is apt to paint some subjects many times. Once having painted this old house I have the feeling that it's mine — I've done it, and I continue to watch its changing moods in the different hours of the day and seasons of the year. I see aspects of it that suggest still other paintings. I could do four or five paintings, one right after the other, without moving too far from that building.

"Here I would like to say, however, that sometimes it's just as important *not* to paint when you go out looking for a subject as it is to paint. Confronted by a place that you think has pictorial possibilities you have to begin by thinking and editing. You have to ask yourself if this building has ever been done by another artist, and who did it, and how? Is it one of those too much painted motifs like the wharves of Rockport? Is it worth doing again?

"If the answer, as far as you're concerned, is *no,* you just go right back home without painting it. On the other hand you could say, 'Damn it, I'm going to do one more painting of this just to see if I can get a different picture.' It very well might work. But you have to keep in mind that you're likely to be competing with paintings that you've already done yourself as well as with paintings by other artists. You have to be careful not to imitate or just to add one more painting to a long list of paintings that could go on ad infinitum.

"So I'd say that the editing process is the first step. If you can't conceptualize something fresh for yourself and different from anything you've seen or done before, don't bother. Wait for another day.

"This doesn't contradict what I've already said about artists painting subjects over and over or my own feeling about being able to do a number of paintings based on one building. It is merely meant to emphasize the importance of coming up with something original, regardless of the subject or how many times it's been painted.

"So in doing my second version of the old house on Gorham Island the initial challenge

was to tell a fresh story. I began by going to the site, without any painting equipment, and walking all around it. I had not been that close to it for three years, although during that interval I had been watching it every time I passed by. But now I went up to the house and said, 'Well, here we go again. I'm going to see what's here to paint.'

"I found that the trees had grown up and the bushes and shrubbery made a jungle that completely changed the scene. At this close range it was now a question of where was there a view of the house that showed a large enough area on which to base a painting?

"Finally it was the old frontal pattern of absolute horizontals and verticals that crystalized in my mind and gave me the underlying structure — my 'Mondrian.' The only materials I had with me were a three-by-five inch scratch pad and an artist's India ink fountain pen. I started to sketch on one of the tiny sheets. When my drawing ran off the edge, I continued it on another sheet. Pretty soon I had a handful of these little pieces of note paper with ink lines on them, like the pieces of a jigsaw puzzle.

"Back in my studio I sorted out these loose sheets, arranged them in proper order, and pasted them down on a piece of gray cardboard. When I saw what I had, I knew that I'd found the skeleton for my painting — the structure, just like the structure of steel beams that's put up when a building is erected.

"The sketch pinned down pretty much what was to go into my painting. At this point another element took shape in the planning, triggered by something that had happened three years before during my first painting of the house. At that time the place was populated with healthy cats of all colors, sizes and shapes. As I sat and painted they played around me in the grass and took various poses all over the porch and lawn. One of them even climbed in my paint box and I had to lift him out. I thought what a pity it was that I couldn't include them, but my time schedule didn't permit it; and, anyway, they didn't seem to be part of the picture idea as I then conceived it.

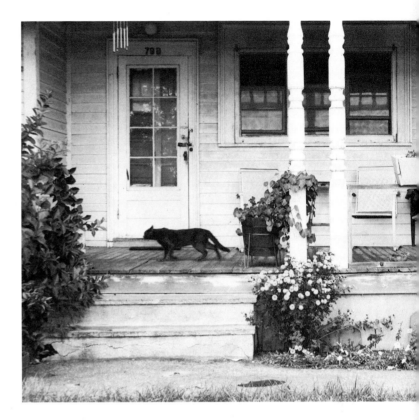

These ingratiating cats — just what's needed for life and interest.

If a cat is reluctant to pose, I go to my picture file and look under C.

I redo the drawing at larger scale onto the canvas. Then make the first color application — blue ink wash. These steps are done in the studio.

"Now, however, with my point of observation closer to the house, I had a clearer and more detailed view of it. In the new version these ingratiating cats provided just what was needed to give an element of life and story interest and make it different from the first.

"Working from the pasted-up original on-the-spot sketches, I made what I call the ink squared drawing. In it I arranged the composition as it will be in the final painting, with particular attention to the placement and balance of dark and light shapes.

"The size that the canvas itself is to be, its shape — whether it's square or oblong — and the careful arrangement of shapes within this format, all these are very important in planning a picture, and I work them out thoroughly before beginning to paint.

"The next step was drawing up the final design on the panel, which consists of a fine weave linen canvas mounted on board. It

has a gesso ground which can take ink, watercolor, tempera . . . anything.

"In making this drawing the verticals and horizontals are so precise that I used a T-square. I have transplanted the huge tree that's actually on the left side of the house, as you can see in the first version, to the right side where it acts as a strong vertical that I feel is needed to hold the design in place on the panel.

"When it came to the cats I went to my picture file. I think an artist should have an extensive file of everything from A to Z. I have five standing file cabinets containing probably two or three hundred thousand pictures, all catalogued and titled.

"I don't have the ability to just tell a cat to sit still in the position in which I want to draw it. When you're as literal a painter as I am, a cat, like everything else, has to be drawn with almost architectural perfection.

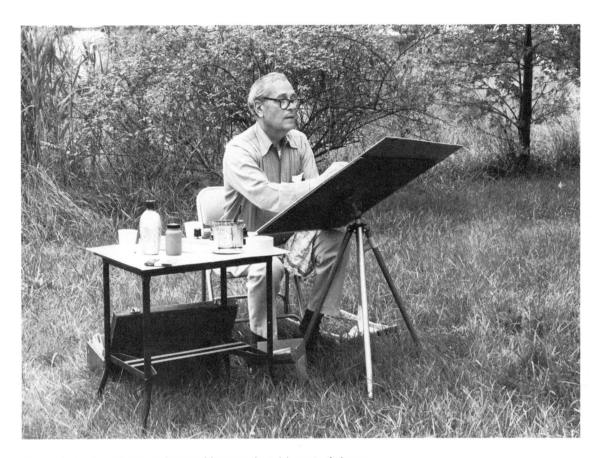

My equipment and set-up for working comfortably out of doors.

If you're working in a more sketchy style, of course, you can quickly indicate an animal that happens to walk into the picture, but in my kind of realism everything has to be in the same sharp focus.

"So in my file, under C, I found my cats and I played around with the arrangement of where they should be in the picture.

"My preparatory drawing included all the very interesting objects and shapes that were scattered around and that, like the house itself, have their own architectural identity. I am so fascinated by common objects and this whole house is one big common object surrounded by many smaller common objects. I don't even ask myself whether these objects say anything. I just put them in — like that little antique carved piece of wood with its Gothic pointed arch and pierced trifoil. It indicates a period and implies that somebody put it there, and

that's sufficient.

"When I was satisfied that the drawing and arranging of all these shapes was complete, I could put aside pencils and T-square. Everything was ready for the pigment, which is usually the truly pleasant part of the job.

"The first color I put down was a waterproof blue ink wash in the sky. It flowed in very nicely. This gesso chalk surface is beautiful to work on. I also put a thin wash of blue in all the glass because windows invariably pick up reflections from the sky to some extent.

"For the most part the drawing on canvas and these first washes were done in my studio; but, fortunately, I live close enough to the old house so that I could go to it conveniently when necessary and check what I was doing. Eventually, however, I took my painting equipment and the canvas panel and set up shop right on the site.

37

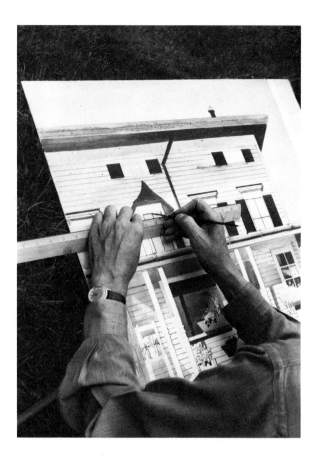

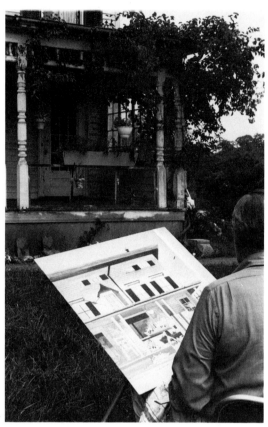

Above and below. The ruler helps to achieve architectural crispness and solidity.

Developing the pattern of darks, as originally indicated in the ink square drawing.

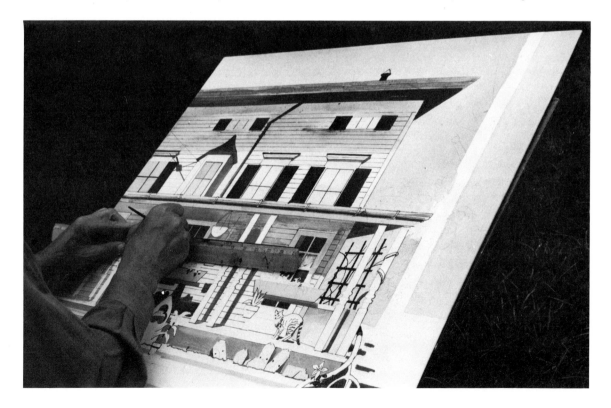

"As you begin a painting it's always a big job to get rid of the raw white surface. My first objective was to cover that awful expanse of canvas — to get rid of the white by putting down areas of color, so I could get to the subject itself. I put in the shadow masses to establish the pattern of the dark shapes. The shutters are the darkest. The clapboard siding has been divided into light and dark areas by the deep shadows under the porch and the cast shadow from the overhanging eaves.

Some of the windows reflect the color of the sky.

Blotting a wash; the effect is visible in the window on the right.

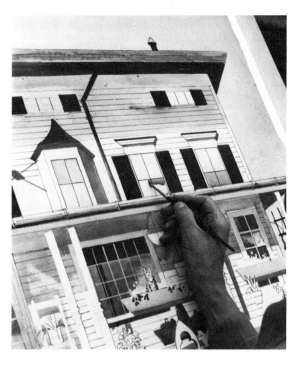

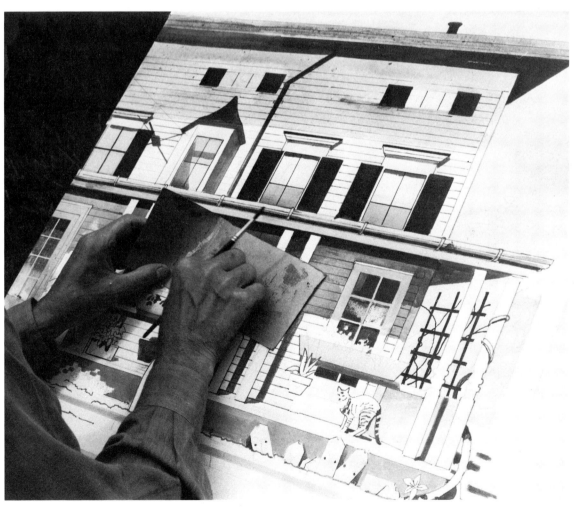

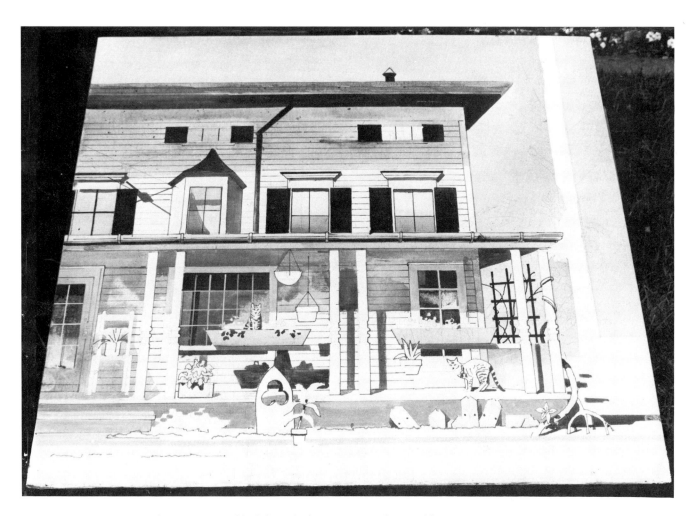

Covering the big areas gets rid of that glaring expanse of raw white canvas.

"I have no qualms about mixing mediums. In the sky I've used a thin wash of colored ink. Most of the rendering of the building, the various objects and the foliage was done with casein. When I think the problem calls for it, I don't even hesitate to over-paint with oil glazes, although I haven't resorted to oil in this painting. I'm not a purist in that I do not stick to one medium.

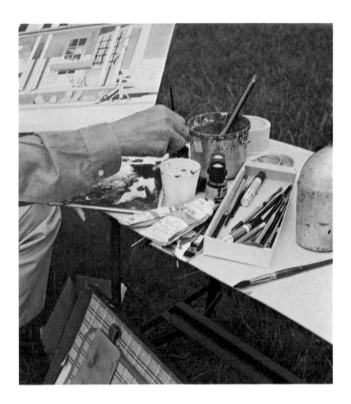

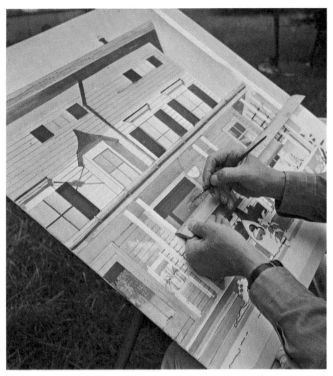

I'm not a purist. As you can see, my materials include waterproof ink and markers as well as caseins.

Window frames are painted in with casein after the interior color has dried.

Shadows divide the white siding into areas of dark and light.

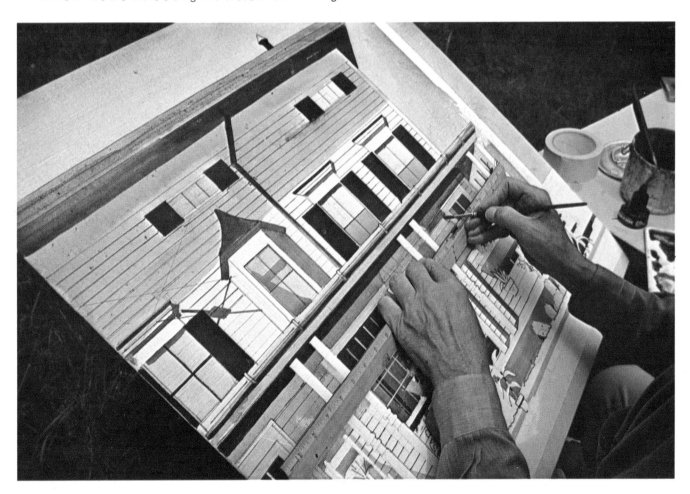

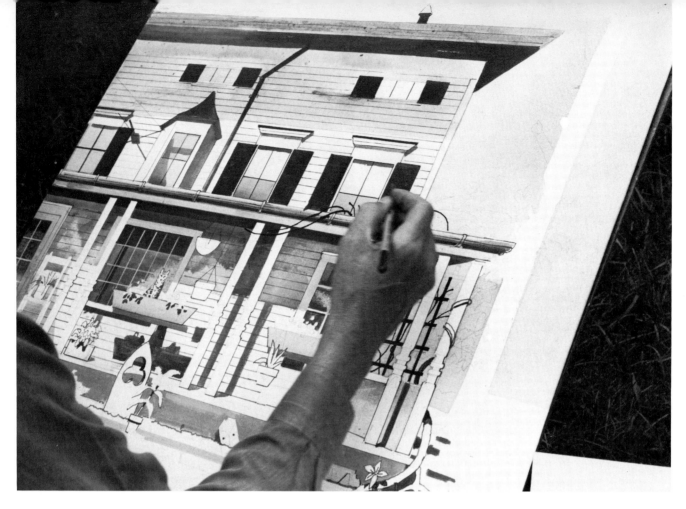

Vines and lattice help give depth to the porch and a feeling of "going around" the corner of the building.

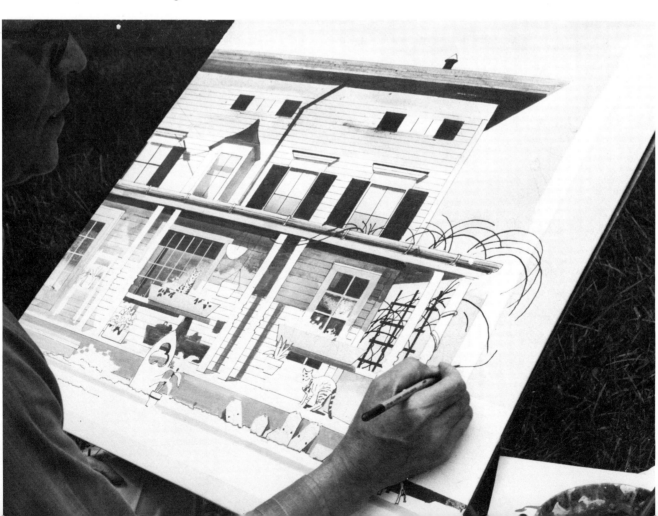

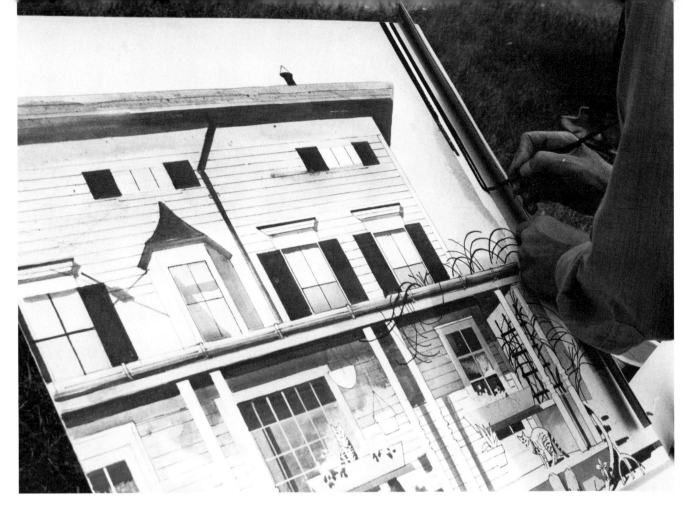

The tree that's actually on the left side of the house has been transposed to the right where it gives needed support to the composition.

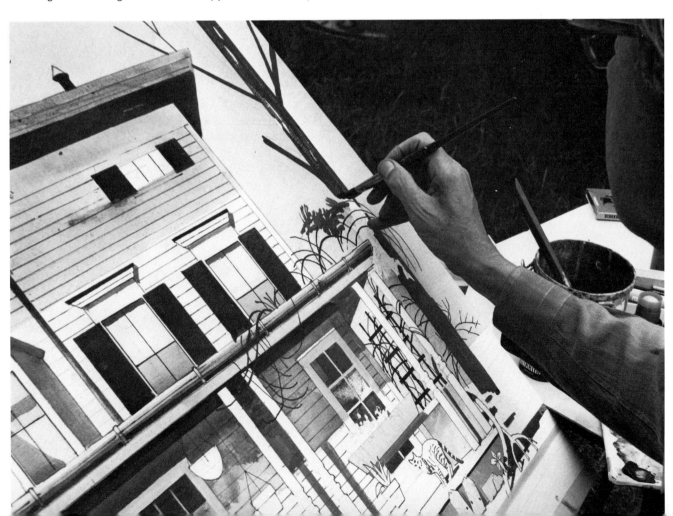

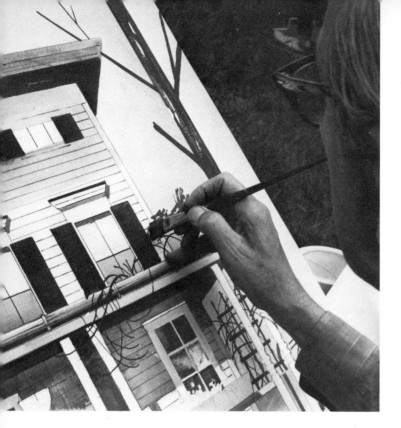

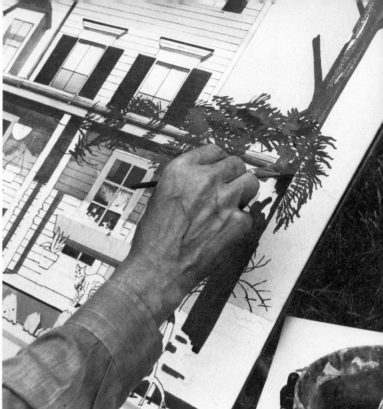

The foliage of the vine is treated as a flat, dark green mass

— over which I paint lighter tones of green to develop the form.

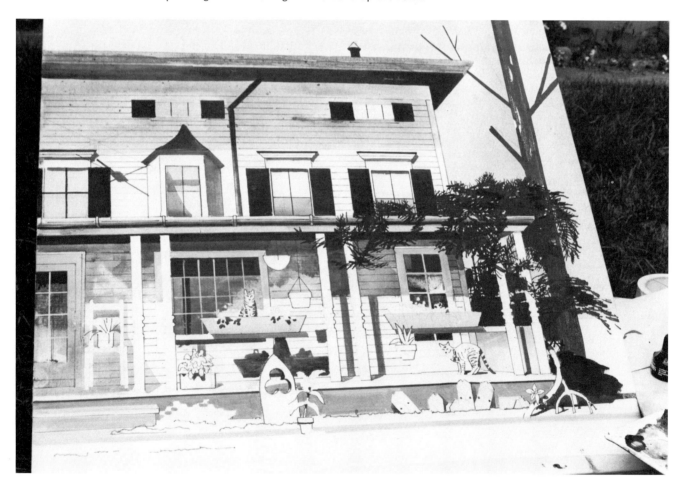

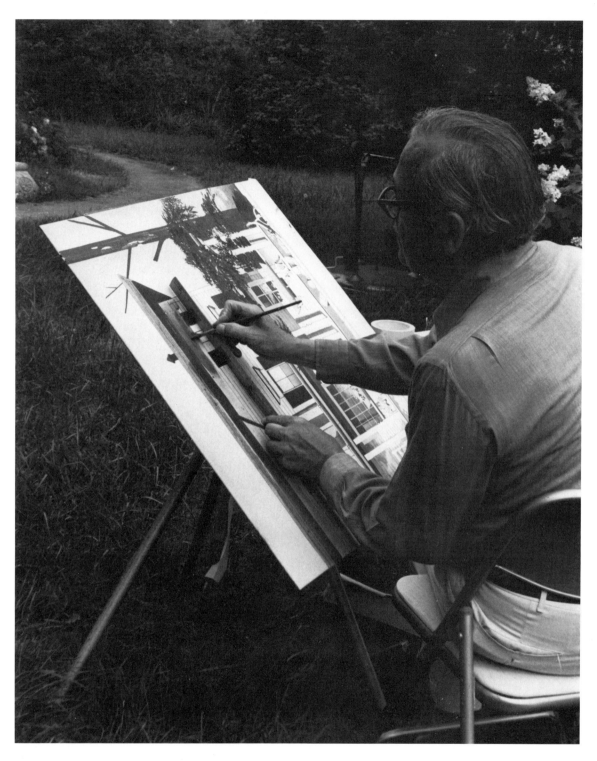

The shadow cast by the broad overhanging eaves is sharp and crisp but not too dark. It must give the impression of reflecting a certain amount of light.

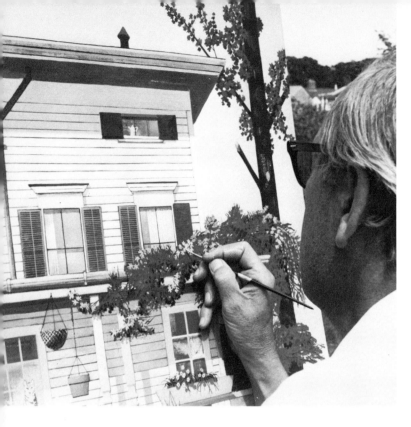

"When I get near the end of a painting, I usually sit and carefully appraise it. I then make myself a list of things that must be done. For example, as I studied the grass in the foreground, I realized that I had to work on the feeling of an unmowed lawn — a look of deep grass that a person could step down into. I noticed, too, that the front door had an interesting pattern made, by the locks that have been added to and changed from time to time. I made a note of this. It indicates that people have been here a long time, and they've tried every way of keeping out intruders.

"I don't try to slavishly copy everything that's in front of my eyes. I select, rearrange, interpret. As I finish the job I check off these final things that I've decided to include. When they're all done I'm ready to sign the painting.

The yellow flowers give a sparkle of warm color.

This is as far as I carried the painting at the site.

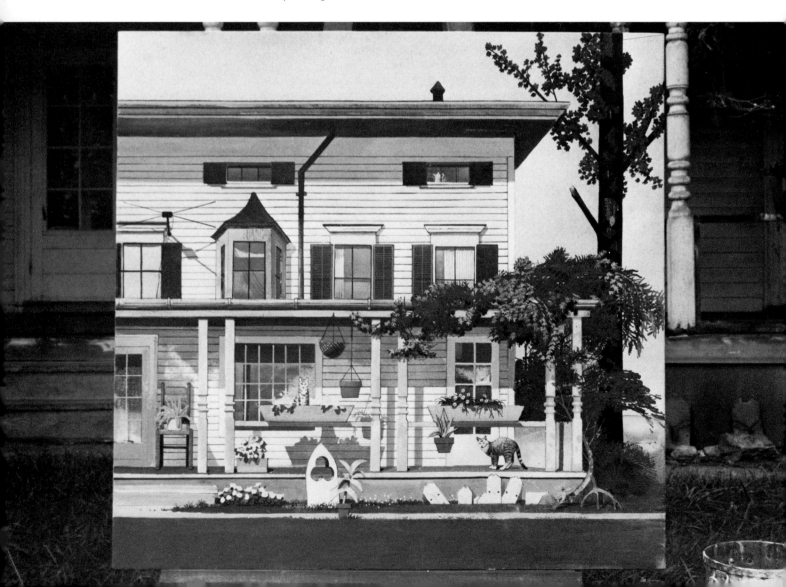

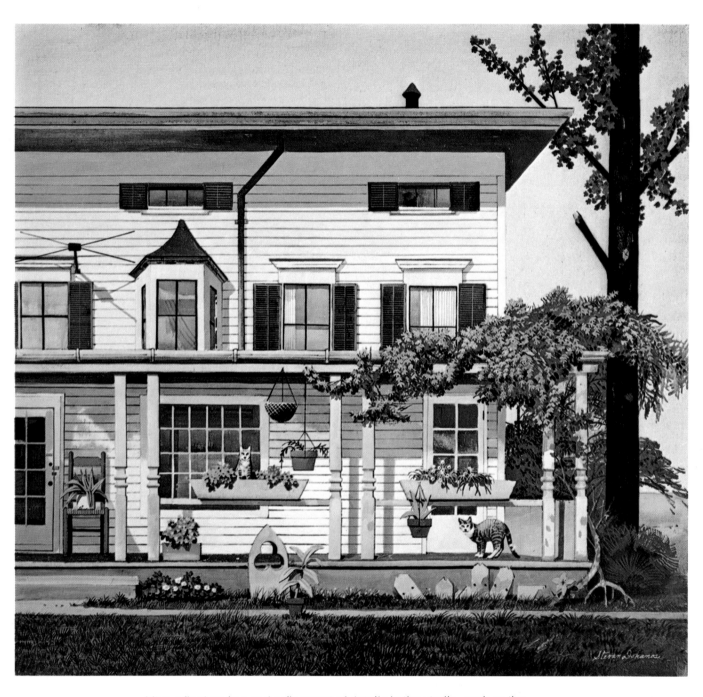

After a final review and refinement of details in the studio, such as the
addition of foreground grass, the picture is finished and signed.

3 HARDIE GRAMATKY

High tide, still water and morning sunlight provide the dramatic mood I'd like to express in my painting of this scene.

The artist at his outdoor easel.

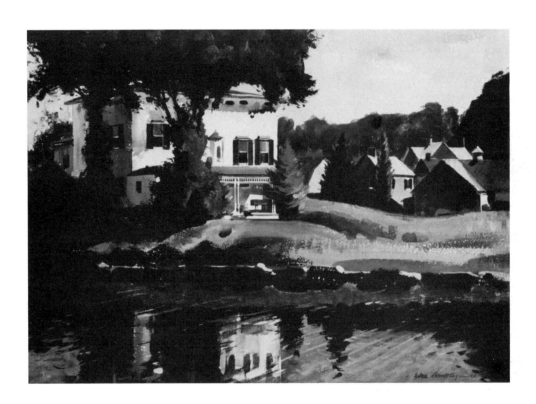

The finished painting.

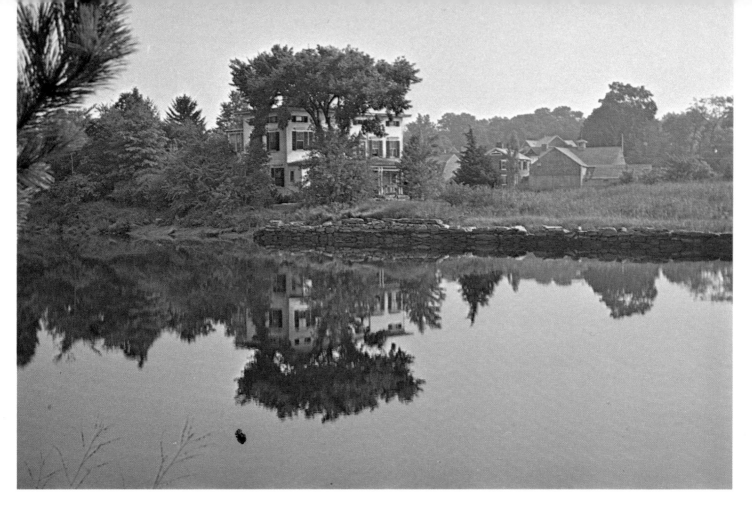

For me color is the keynote to beauty in a painting. I begin the color planning in my first sketches.

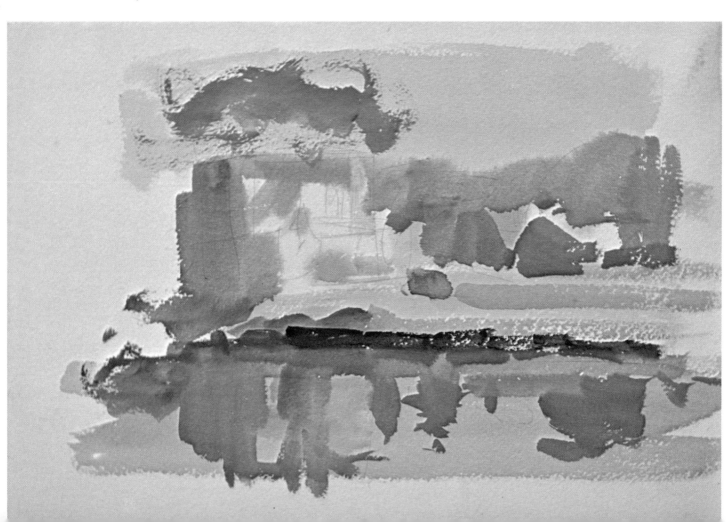

Hardie Gramatky's watercolors, glowing and sparkling with outdoor light, are the products of joy and enthusiasm as much as proficiency with brushes and paint. Watching him paint is like watching a seagull fly. Both perform spontaneously and with evident relish, each practicing his respective skill with what appears to be effortless mastery of a difficult art.

Like the seagull he has been on the wing, as it were, since he was out of the nest. While still a high school sophomore he sold editorial cartoons to the Los Angeles Herald. Walt Disney liked his drawings well enough to hire him and for six years he was chief animator in the Disney studio.

It was at the Chouinard Art Institute in Los Angeles, however, that he discovered the excitement and satisfaction of painting from nature, particularly in watercolor. Later, as a free-lance artist living in New York and Connecticut, he was gratified to find his paintings winning him advertising accounts and recognition from industry, as well as prizes in fine arts exhibitions.

The charm and vitality that characterize everything this artist does are no where more evident than in his books for children. LITTLE TOOT, the protagonist of several picture books and a Disney film, is doubtlessly the best known and most loved tugboat in the world.

In addition to numerous awards for his books, Hardie Gramatky has won over forty top watercolor prizes. He is a member of the National Academy, the American Watercolor Society, The Society of Illustrators and the Author's Guild. His work has been exhibited in many of the foremost museums and galleries of America and in Europe, India, Pakistan and the Philippines. His pictures are in the permanent collections of the Brooklyn Museum, the Chicago Art Institute, the Toledo Museum of Art, the Museum of Fine Arts in Springfield, Mass., and many private collections.

Herewith, in a characteristic blend of practical philosophy and boundless enthusiasm, the artist comments as he paints a watercolor.

"You can't force things when you work from nature. Your first reaction to a scene might be, "this is great, let's get right in there and paint it." But nature is so abundant, so full of great things to tell you, that it's good to just sit there for about ten or fifteen minutes, to enjoy nature and let it come to you.

"There's always the danger of approaching a problem with too many preconceived notions. I've painted my best pictures by almost completely reversing my whole original thinking about something I've set out to do. There's so much that you don't see at first glance. It's important to let it all take hold of you and carry you with it.

"As I make my first sketches I like to kind of fool around with them and keep looking for what is pertinent. Pretty soon the subject involves me. I begin to get excited. Usually I try out several experimental sketches, both black-and-white and in color, to see what the compositional possibilities are. I move around to find the best view and the best light. In this case I arrived at a long shot, in which I got the water and that wonderful reflection in the foreground . . . also a lot of small buildings and roof tops behind the big white house.

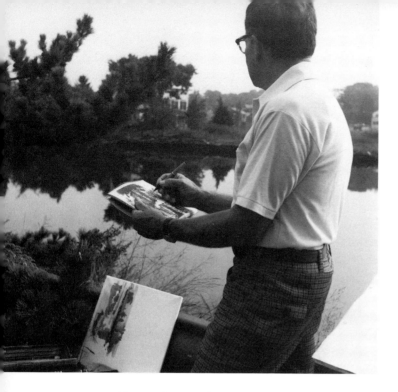

The preliminary sketches get me involved with the subject and help me find what is pertinent.

I do a number of sketches, in color and in black-and-white, to explore thoroughly the compositional possibilities. When I have a version I like, I redraw it at larger scale on watercolor paper tacked to a drawing board.

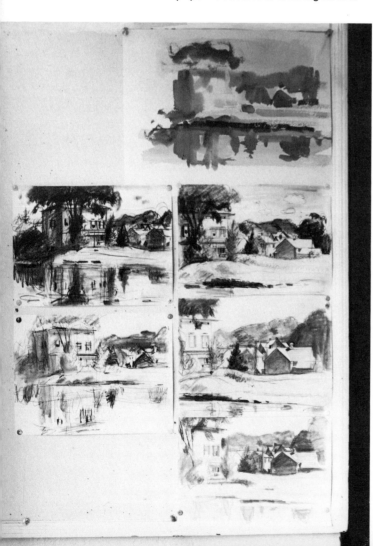

"I want to suggest that this is a lonely old house, but also that there's this little village beyond, so that there's a contrast, something to give the feeling of drama — this beautiful place facing the river and behind it the village. I don't want to make too much of the village, but just try to get the feeling that it's there, and is part of a way of life.

"As I plan how I'm going to go about organizing my picture, I let my eyes roam all over the scene. Everything relates. I look for the mutual interaction between line, color, form. Too many people get involved with little individual parts. But everything's related in a composition, everything lends itself to one statement. Nature is the greatest organizer, and when you look at a scene that you've chosen to paint you should try to see it as an organized whole.

"My pencil drawing on the watercolor paper is made from the preliminary sketches. It's just a very simple indication of placement and space-breaking, without much detail. I do this step in the studio, then make the few necessary corrections when I go back on the spot, ready to begin painting. The worst thing is to go out without any concept at all and flounder around — unless your primary purpose is just to make sketches as such. That's a different story. Lots of times I'll go exploring just to do small color sketches, say ten by twelve inches or a little larger. Sometimes I'll pull off a lovely little watercolor this way but it's usually not a finished thing that will stand close inspection.

"So those first little sketches I did become very important. They're the basis for the pencil drawing on the watercolor paper and this, in turn, permits me the freedom of thought I'll need while I'm doing the actual painting.

"I don't necessarily have a fixed palette but I do tend to keep to certain transparent colors that I've worked with all my life. These include cadmium scarlet; Winsor red; alizarin crimson; cadmium yellow pale; cadmium lemon; yellow ochre; raw sienna; burnt sienna; burnt umber; Hooker's green; Winsor blue; cobalt blue; Payne's gray. Very little black.

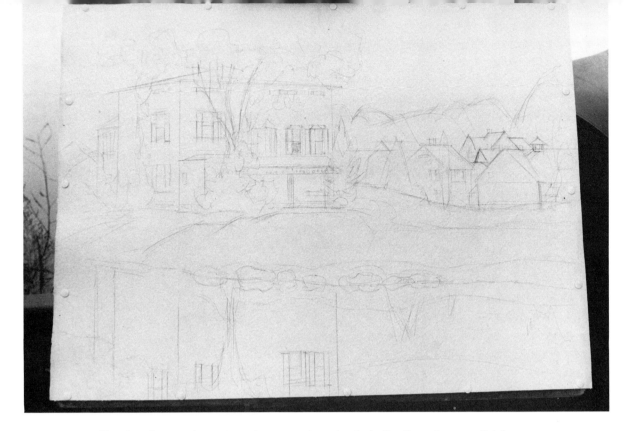

The drawing on the watercolor paper is a simple indication of space division, without much detail. A T-square assures that the architectural lines are straight and true.

My palette is a white enamel butcher's tray. The table enables me to work standing up.

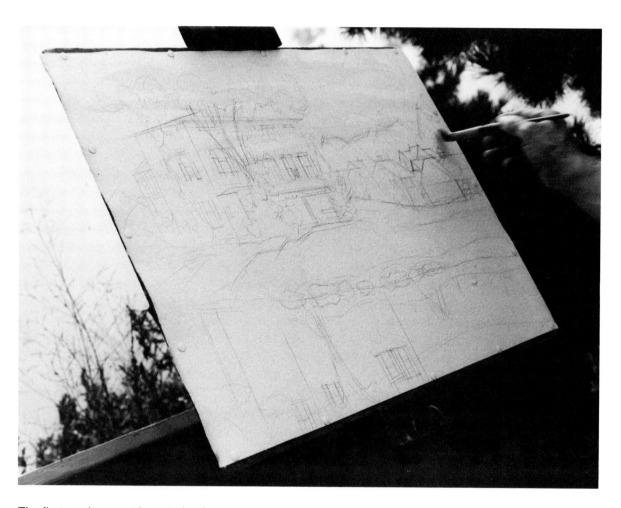

The first washes are big and simple.

"Some watercolorists don't use opaque but I'm not against a little white mixed with my colors here and there. I believe that you should carry a watercolor transparently as far as you can go. But where you might need a little cool — in the sky or the water, on an edge or two — the use of white can give a sense of vibration of color and a change of pace that you can't get any other way. For this I prefer a good poster white, which I can use straight or mix with the transparents to produce opaques.

"The first washes should be big and simple. Start with the big value areas and get their proper relationships in terms of dark and light. At the same time let the excitement of color play freely. Nature's so full of color that you can start a thing like this with terrifically strong color, which I think of as the underpainting. Here, for example, I brush in a large area of lemon yellow over the whole central part of the paper. Then I put green over that. I keep building color on color and in this way get a feeling of light coming through from underneath — a vibrancy of color gives life to the painting. You can always soften it a little with over-washes to turn some of the edges or keep it from getting too garish.

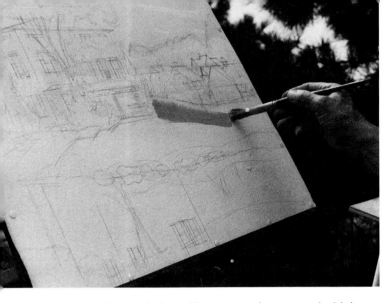

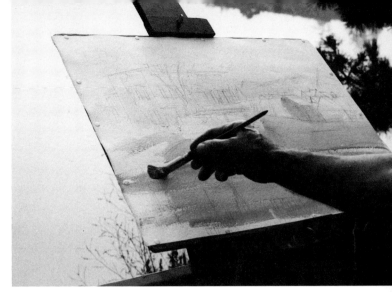

I begin a painting with strong color, most of which will be overpainted with successive washes.

As the painting develops I keep working broadly, with an eye to its all-over unity.

When the big value areas have been established I can begin spotting in exciting bits of local color.

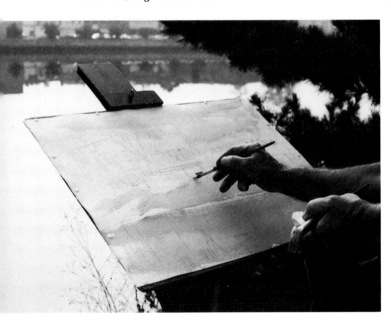

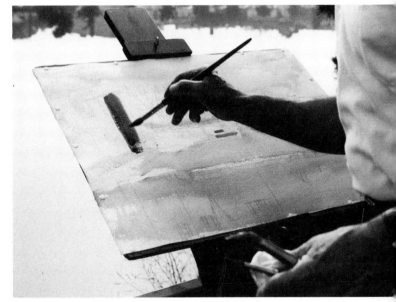

Below. I keep the shadows lively by using the full-strength local color mixed with its opposite on the color wheel. For example, a little violet can darken a yellow without deadening it, a bit of red or orange can tone down a green.

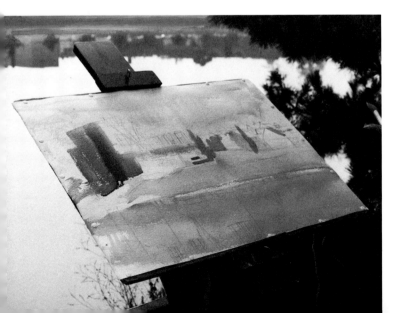

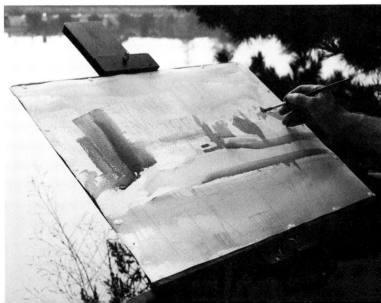

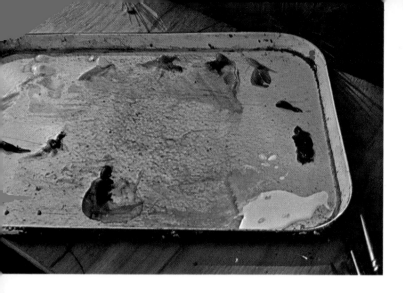

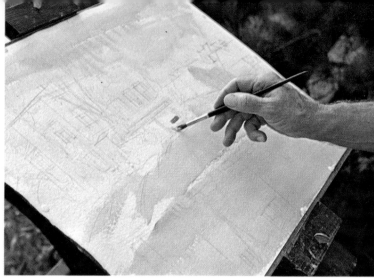

I go as far as possible with the transparent colors, but there's nothing wrong with using white where it's needed for a change of texture, to cool a color, or to produce a particular effect.

An initial wash of lemon yellow gives a bright undercoat.

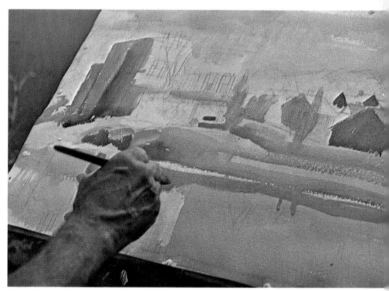

I begin laying colors and values over the entire area.

Building one color over another produces a bright, sparkling quality. The light seems to be reflecting through from underneath.

As soon as the yellow wash is dry I can brush other colors over it.

Color and value should be developed together so that they relate.

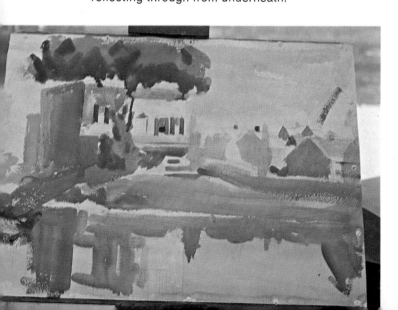

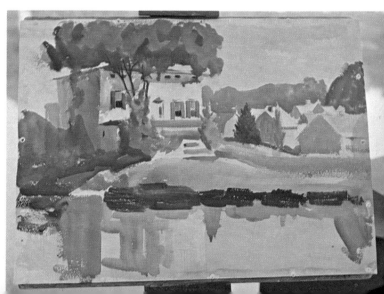

"Now I begin putting in bits of local color, which I'm very excited about, always keeping in mind the big value areas and their inter-relationship. For shadows I use the local color mixed with its opposite on the color wheel. I get a tremendous charge out of good color relations. Everything in the composition is related, everything is for one purpose. My eyes keep roving all over the painting as it develops and I try to keep an all-over unity.

"The center of interest is in that little front porch. There's a concentration of jewel-like color around the blue flower box with the bright blossoms in it. In contrast to the cool colors of the porch and all that green that sets a keynote around the house, there's the cluster of buildings in the background, with their warm colors.

The triangular gables of the background buildings suggest a geometric motif that repeats itself in other parts of the painting and helps to unify the composition.

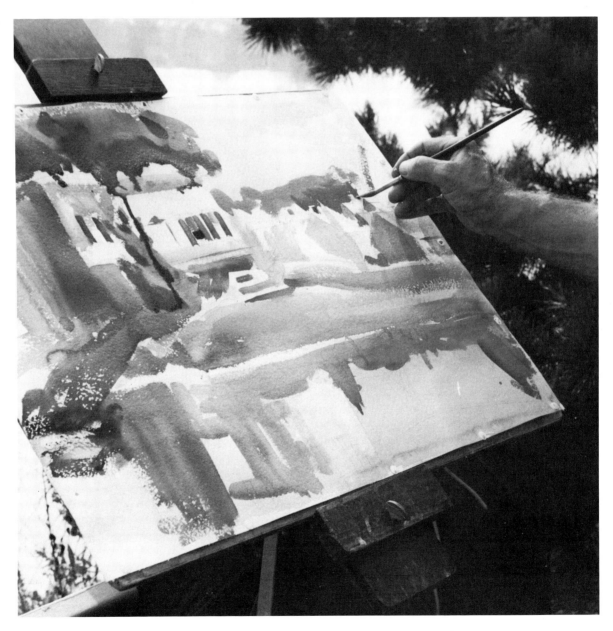

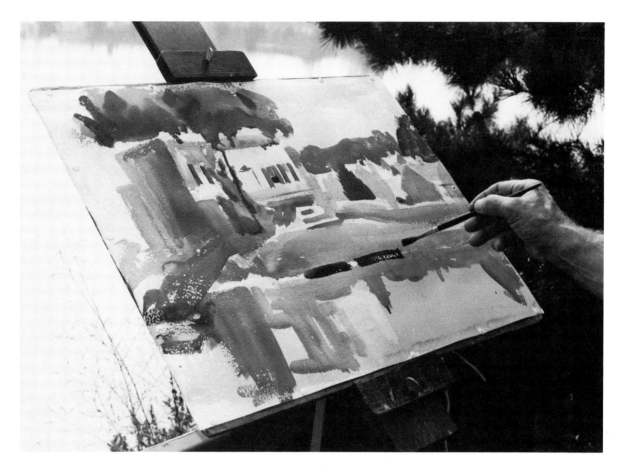

Not until the big bold initial statements are down on paper do I begin to think about refining the particular parts of the painting.

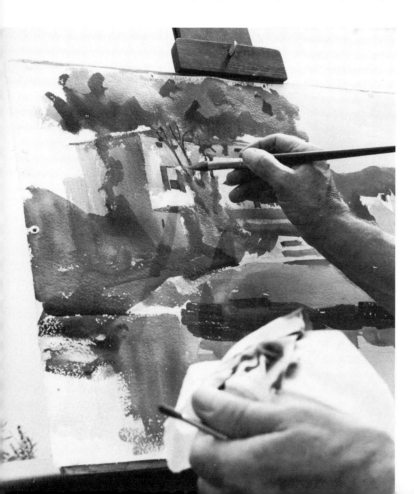

Not too much detail. Simplify and eliminate, leaving only what has meaning to the composition and drama.

"Accents are so important. Every now and then I put in an accent where I feel it's needed. These are little notes of strong value or strong color that serve to separate shapes and planes and lend a crispness and authority to the complete pattern.

"Often I can find a shape that repeats itself throughout the composition. I see it here in the triangles made by the gables of those background buildings. The triangle becomes a motif that helps achieve a certain unity in the picture. I pick it up in the triangular masses of foliage, in the shapes of shadows, in reflections in the water — all over the picture surface.

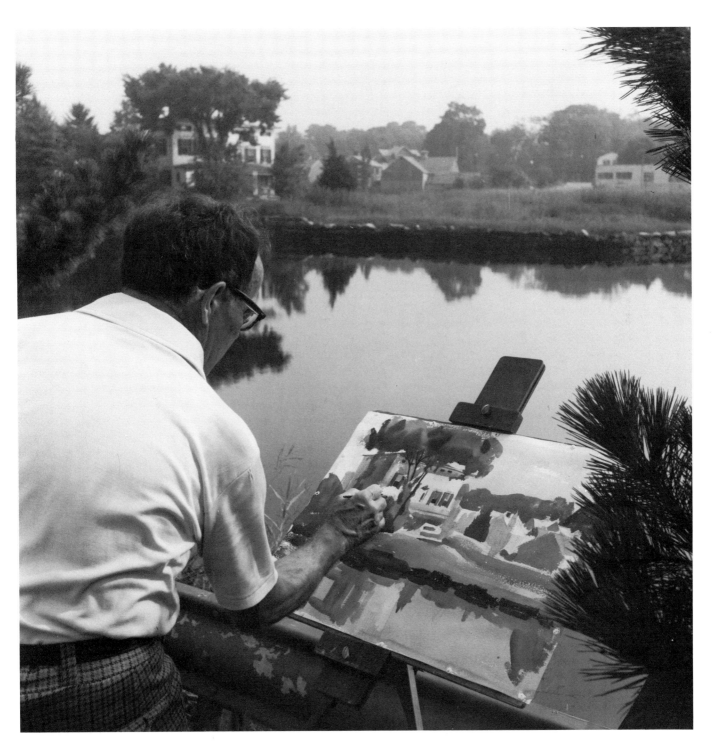

I like to use the full range of values, from strong darks to sparkling whites.

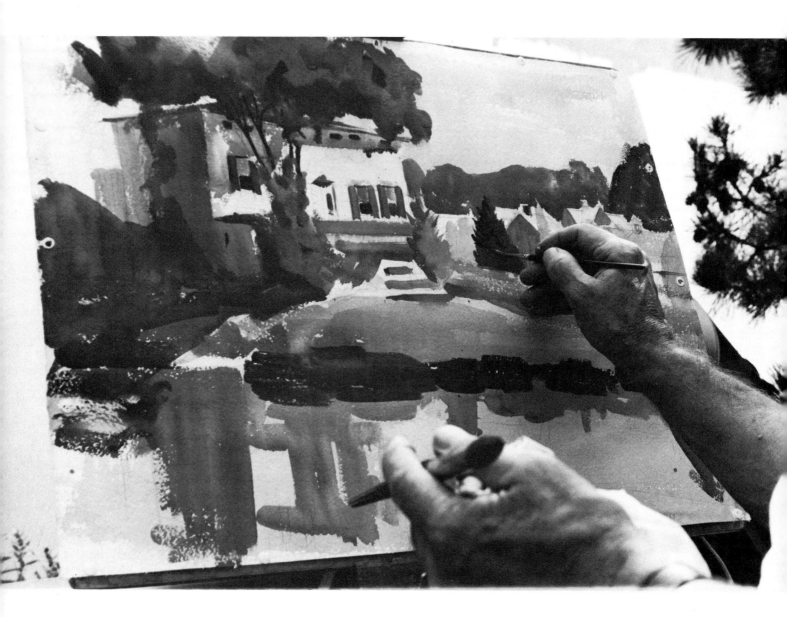

As I paint, color builds on color until I feel as though I'm racing to keep up.

"You begin to refine the big and bold statements as you go along. Painting should be a lot of fun. It shouldn't be any labor at all. When I get going on a painting, I'm carried away. Colors build until pretty soon it's going so fast that I seem to be racing along to keep up. That's the way the joy of painting should be. If a color runs, that's all right. Watercolor is supposed to run. I enjoy the little accidents, the surprise element, the way a thing will often come out so much better than you anticipated because you let yourself be

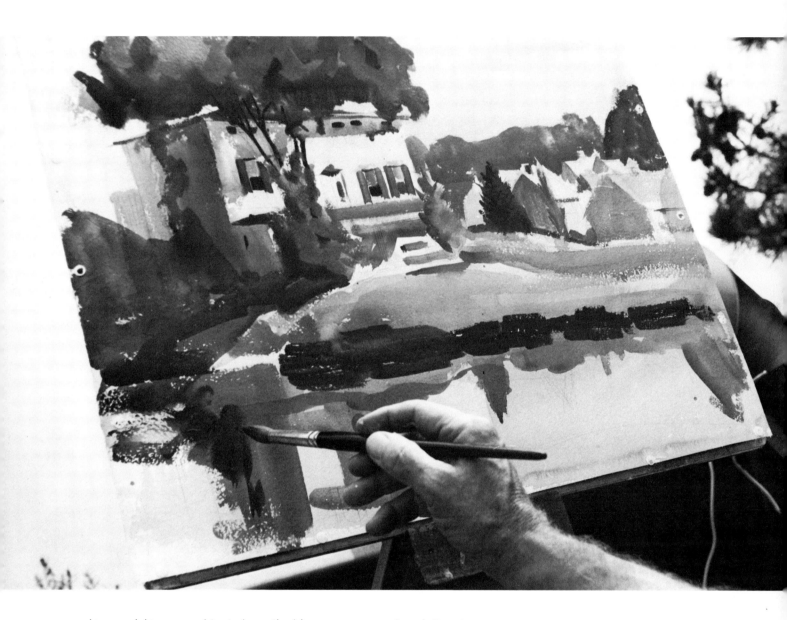

In organizing space, I try to keep the big areas open and uncluttered.
I think of them as rest areas for the eyes.

carried along.

"You shouldn't be afraid of a watercolor. Throw color onto the paper with the idea that you can change it. Before it's dry you can do anything you want with that color. You can soften it, harden it, lighten it, darken it, make it more vivid, or whatever. I can tell when a painting's going badly because I begin to feel as though I'm carrying a burden. When that happens I just start over again. But when it's going well all over for you, it's almost like a musical score — everything is singing.

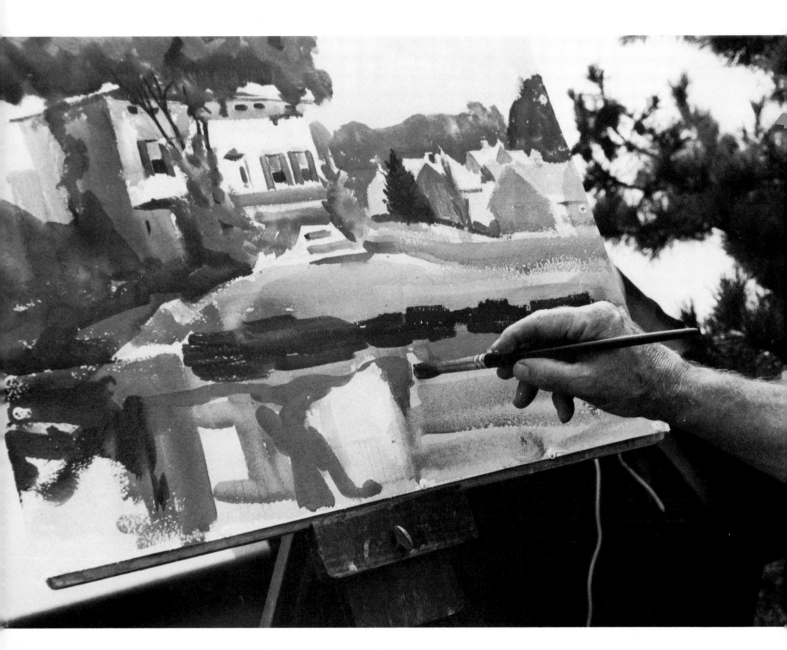

Reflections are exciting to paint, but some restraint must be exercised to keep them subordinate, in color and contrast, to the forms reflected.

"As the painting develops, I have to keep concentrating on the drama of it — on emphasizing whatever it is I most want to tell. It's as though I were a stage director for a play or a movie.

"I think of a painting and the act of doing it as energy directed in space. The artist plays one thing against another — shape against shape, dark value against light, warm color against cool; in this way he communicates to the viewer that something intriguing is going on, that this is not just a pretty picture but something visually and emotionally stimulating, in which there are forces and conflicts and tensions, as there are in nature itself.

Painting with watercolor is full of surprises. Little accidents and unexpected happenings often turn out better than anything you expected if you let yourself go along with them.

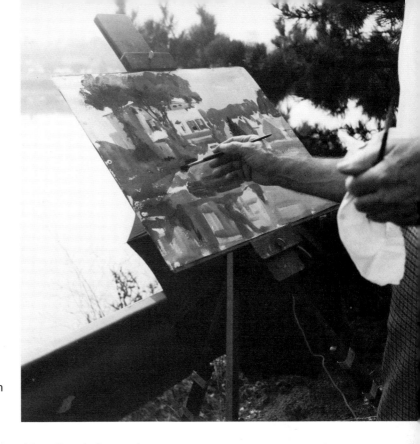

There comes a time when I've gone as far as I can working directly from nature. Then I move back to the studio.

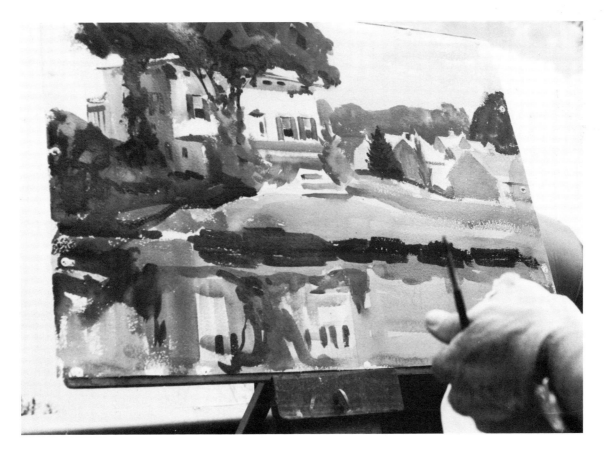

63

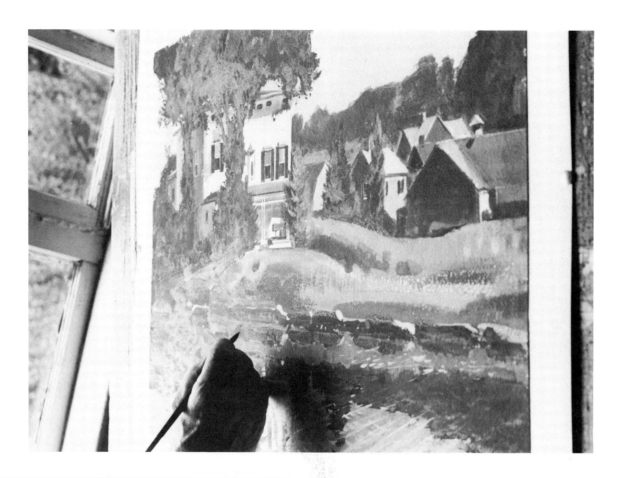

The significance of line, color and form
is in their mutual interaction.

The last finishing touches.

"There comes a point when I move back to
the studio for the finish. Working on the
scene I've gone about as far as I can with my
transparent washes. I refer to them as
transparent even though, as I've said, I mixed
a little white with some of them. But now, in
finishing, I use heavier opaque, especially on
the surfaces that face upward, like the surface
of the water. The final statement is the feeling
of the sky reflecting light down. There's a
kind of play of broken washes, with the color
underneath coming through and the opaque
surfaces reflecting the light from above.
 "The mood, the harmony, the charm of a
painting are what count in the end. Values,
light and dark pattern, a feeling of drama —
all these are more important than details."

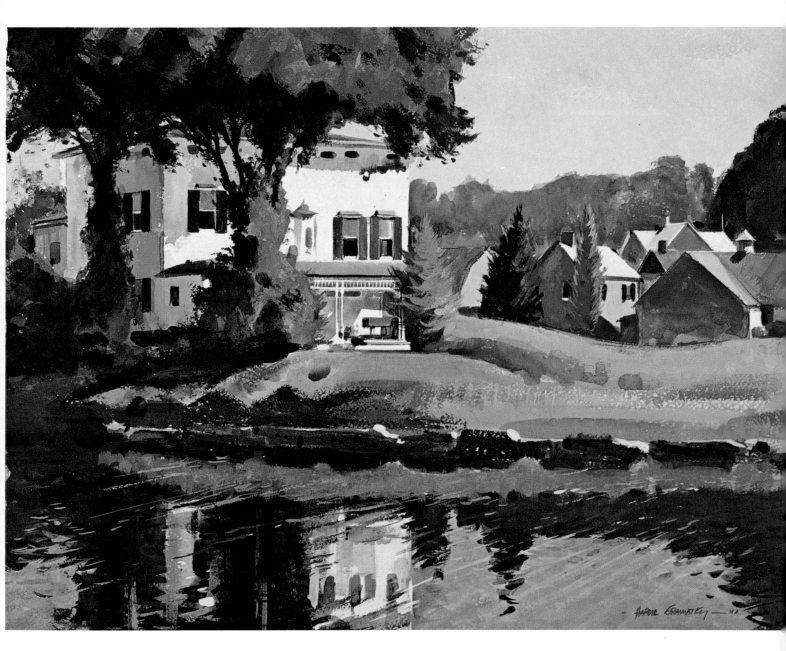

The completed painting.

4 JOHN PELLEW

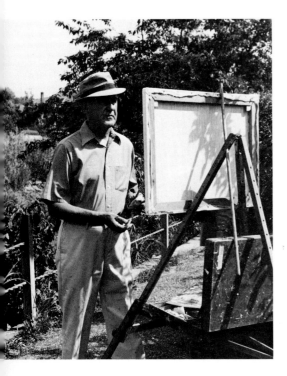 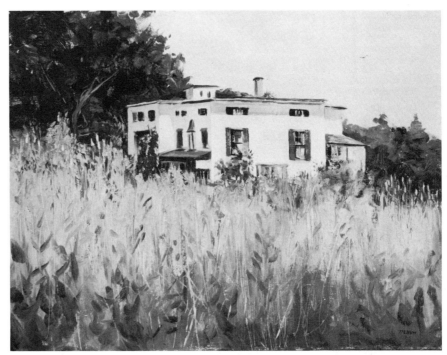

The fastest brush in the East and West. His interpretation

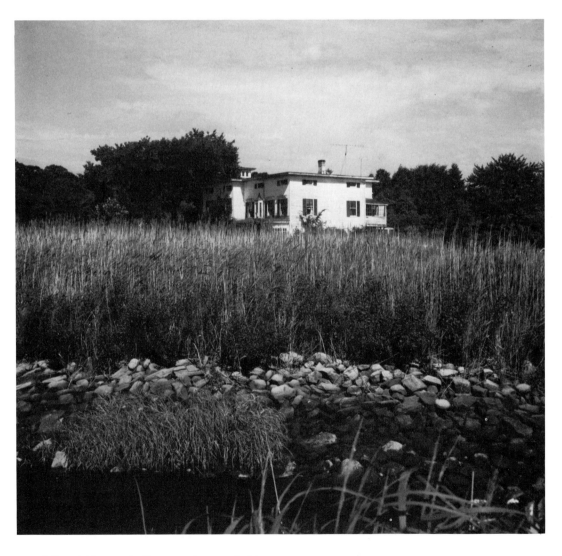

— of the old house in the morning sunlight.

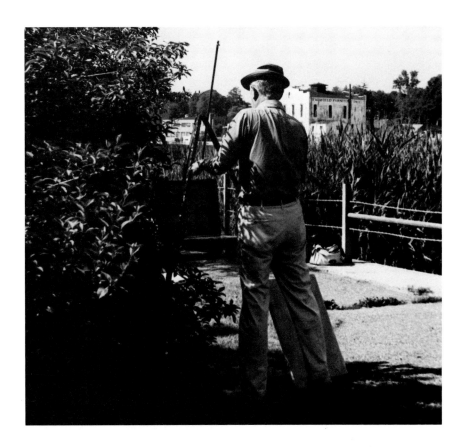

I like to work standing up. I'm standing with my back to the subject to keep the glare of sunlight off my canvas.

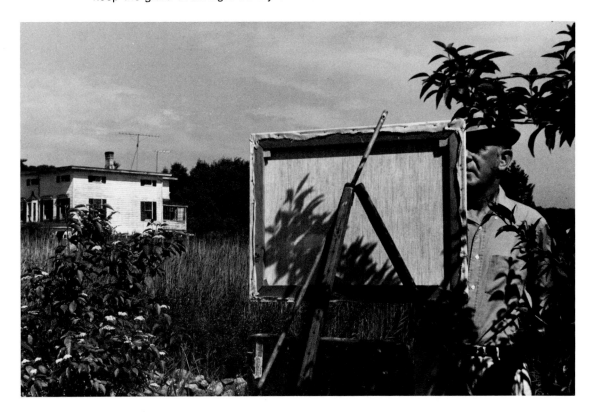

During a painting workshop in Texas a group of students was impressed — as many have been before and since — by the speed with which visiting instructor John Pellew completed a demonstration painting. In response he quipped that he was known as "the fastest brush in the East."

The next morning he was greeted by a hastily lettered sign: Welcome Mr. Pellew — the fastest brush in the East *and* the West.

The sign hangs on a wall of Jack Pellew's compact, tidy studio in Westport, Connecticut. It is only one souvenir in a long list of prizes, honors and awards that, if spread among half-a-dozen artists, would still allow each a fair share of glory.

Regardless of time spent in execution, it's the quality of the finished work that counts. Not only is Pellew's mastery of technique evident in even his slightest outdoor sketches, but his paintings convey a warm personal sentiment in regard to a world which, thankfully, is still blessed with fields and woods, lonely moors and rocky coasts — landscapes that man has marred with nothing more unsightly than back roads, farm houses and barns, wharves and boats and fishermen's shacks.

Born in Cornwall, England, where he began his art education in night classes, John Pellew came to the United States with his parents when he was a boy. He studied at the Art Students' League of New York under Boardman Robinson. On completing his art studies — if any artist ever does — he launched into a professional career in which he distinguished himself as a commercial artist, an art director for many years at Collier's magazine, a landscape painter, a teacher, and the author of several books on painting.

It is as an outdoor painter and a teacher of landscape painting that he is best known today. He is in much demand for his lecture demonstrations and workshops. Fortunate indeed are the artist travelers — be they students, amateurs or professionals — who go with him on the painting trips he leads several times a year to various colorful parts of the world.

Among the numerous collections in which he is represented are those of the Metropolitan Museum of Art, the Brooklyn Museum, The New Britain (Connecticut) Museum of American Art, The Georgia Museum of Fine Arts, and the Butler Institute of American Art of Youngstown, Ohio.

He is a member of The National Academy of Design, The Allied Artists of America, The American Watercolor Society, the Connecticut Watercolor Society, The Fairfield Watercolor Group and the Salmagundi Club.

In words and pictures the following pages record a typical Pellew painting demonstration.

"It's fun to travel, to see new sights and paint them, but I think an artist usually paints best the things he knows best.

"In choosing subjects, there's often the temptation to focus on the picturesque, the obviously charming New England covered bridge or the thatch-roofed Irish cottage with roses around the door — things and places that have been painted so often that it's hard to interpret them in any new and interesting way. Which doesn't mean that an artist can't make something good out of any subject, no matter how often it's been done before. It's not what you paint so much as it is how you paint it.

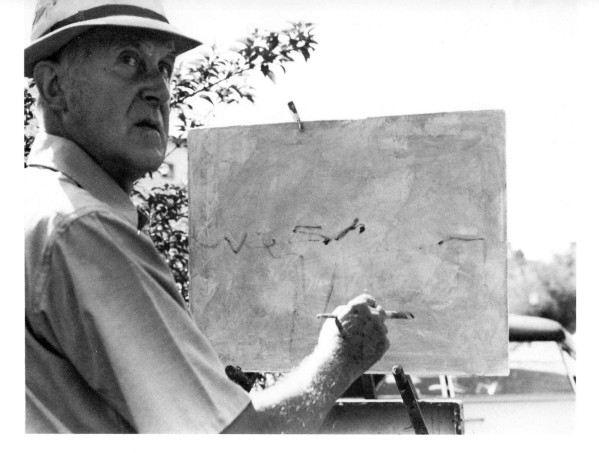

Painting with your back to the subject brings your memory into play, and in that way keeps you from getting involved with unessential details.

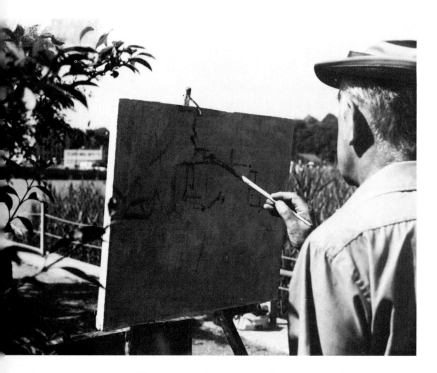

The canvas is covered with a wash of burnt sienna thinned with turpentine, so that I won't have to work on a glaring white ground.

Below.
As I set out the paint on the palette I mix a little medium with each color so that the medium will be distributed evenly through the painting.

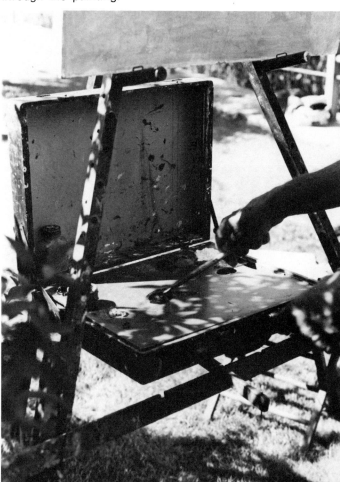

70

The drawing is sketchy and without detail. I do it with a small bristle brush and burnt umber directly on the toned canvas.

Out-of-doors I feel equally at ease working with oil, watercolor or acrylic. Subject matter doesn't determine the medium I'm going to work in so much as the way I feel. If I know I'm going to want to use the palette knife a good deal, then the choice is oil. Such is the case here, in painting the old house on Gorham Island.

"In the field I like to work standing up. There's always the business of carrying all your equipment, and if you take along a chair or stool it's another piece to worry about.

"In setting up my easel I'm standing with my back to the subject. Otherwise the sun would be striking directly on the canvas and making too much of a glare. Moreover, when you're painting with your back to the subject you're painting to a certain extent from memory. And as Robert Henri once said, 'The beauty of painting from memory is that so much is forgotten.' He meant, of course, that 'so much' is unessential to a good painting.

"My canvas is raw linen, primed with white oil paint and toned with a wash of burnt sienna thinned with turpentine. I cover the canvas with this tone so I won't have to work on a glaring white ground. Sometimes, instead of sienna, I'll use umber and white

for a cooler tone.

"No matter what subject I'm painting I set up my palette with the same colors — cadmium yellow light; yellow ochre; cadmium orange; cadmium red light; burnt sienna; burnt umber; cerulean blue; thalo blue; and, of course, white.

"Usually, when I'm painting outdoors, I mix a little medium with each mound of paint. In this way the medium gets distributed evenly throughout the picture. This particular medium is one I mixed myself. It's an old standard of equal parts linseed oil, turpentine and copal varnish. There are plenty of other good mediums, but every artist has a favorite. One of the simplest and easiest, which I understand Renoir used, is simply equal parts of linseed oil and turpentine.

"I sketch in the drawing with a small brush and some burnt umber thinned with a little of the medium. Sometimes I feel that it's necessary to make changes in what the eyes see. One shouldn't hesitate to take liberties with nature if the composition can be improved by doing so. As an example, I've lowered the tree line which actually is above the roof on the right side of the house. I think that the design is made more interesting by including a larger area of the sky.

I use the palette knife almost as much as I do the brushes. The basic sky tone is white and yellow ochre. Into this I later work other colors.

"I don't go into detail with the drawing. It's largely a matter of putting down the big shapes where I want them. Then the drawing continues with the brush as I paint. It isn't necessary to draw all the little details because they're only going to be suggested anyway in the finished painting.

"It seems to me that outdoor painting should be considered no more nor less than a sketch in paint, which is quite a different thing from a painting done in the studio. Many beginners, when they paint outdoors, try for too much finish. They take so much time putting in unimportant details that the light changes, which can be very confusing. At best they get a labored kind of result that's not really what I consider an outdoor painting. It's better to do the painting quickly on the spot and then

use it later to work from in the studio where there's more time for elaboration and contemplation.

"I make generous use of the palette knife as well as the brushes. It's a way of getting the canvas covered rapidly and that's the whole secret — put it down as fast as you can. Changing light, weather, persistent insects and onlookers, all make speed necessary.

"Get plenty of paint on the canvas right from the beginning. That's another reason I like the palette knife. For most fair-weather skies I begin with a mixture of white and yellow ochre. Then I paint my other colors into this. The blue is predominantly thalo blue and white. In the lower part of the sky I add a little cadmium red light, because it's warmer down toward the horizon.

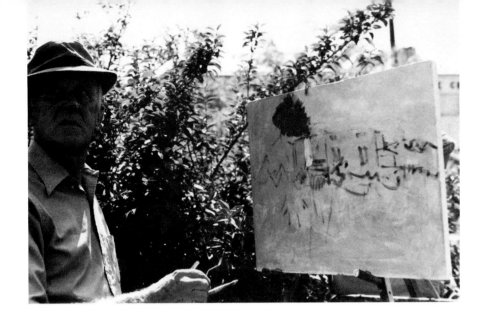

The secret of outdoor painting is to put it all down as fast as you can.

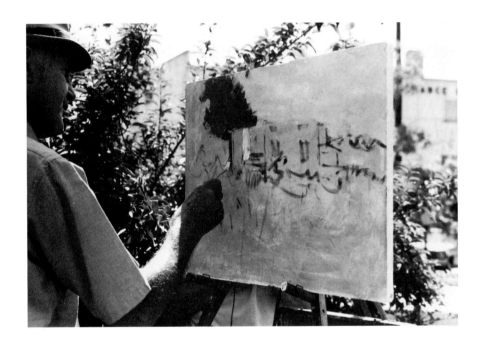

The tree foliage around the house establishes a dark value to which I will key all other values as I develop the painting.

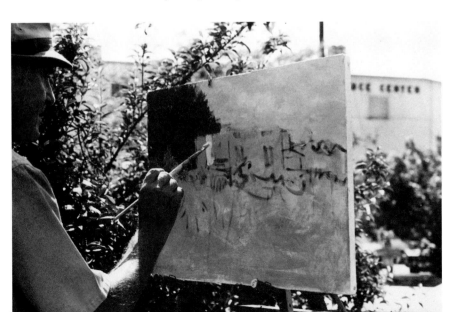

73

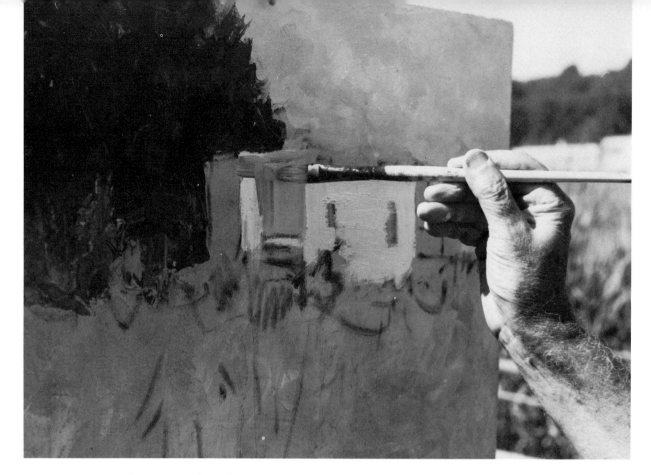

Look first for the big main shapes. After these have been determined, I set down their comparative tonal values.

Sometimes it helps the composition to take liberties with what the eyes see. Here I've lowered the tree line which actually is higher than the roof on the right side of the house.

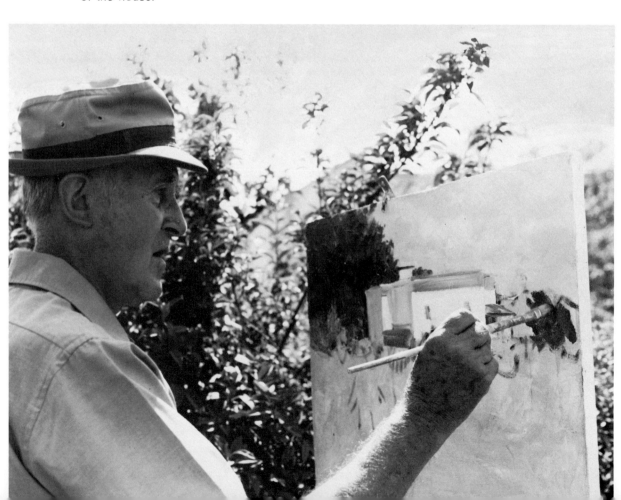

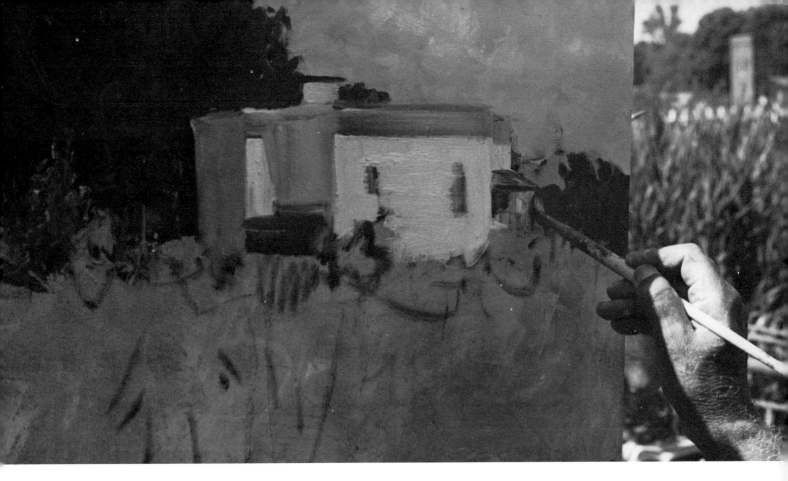

Let the brush strokes show — they're the artist's handwriting.

"As I get into the greens of the tree foliage around the house I'm establishing a dark that gives me a fixed value to serve as a standard of comparison by which to judge my other values.

"There's no green included among the colors laid out on my palette. I prefer to mix my own as I go along. A mixture of raw sienna and thalo blue gives me, I think, a more interesting color than any prepared green that comes directly from a tube. I can make variations by changing the proportions of sienna and blue in the mixture, and by using yellow and yellow ochre for warmer, lighter greens, and my other blues for cooler, darker greens.

"Color, in my opinion, is not as important as tonal value. Color is a very personal thing. Three or four painters, standing here painting this same scene, would probably each come up with a different color scheme and a different picture. That's what makes painting interesting, of course — the personal style of every artist.

"Tonal values, the relationship of darks, half tones and lights to each other, is something more tangible than color. This is difficult for some beginners to understand. The best way to understand values is to observe, to look and see what is dark, what is light and what is in between, and to keep comparing these values to each other over the entire surface of the painting as well as in nature itself.

"Always look for the big main shapes because a picture, before it's anything, is an arrangement of shapes on a flat surface. And after you've put down the main shapes, then look for their values. By putting down a spot of paint that you've decided is going to represent your darkest dark you give yourself something to key the rest of your values to. It can be very dark or not so dark, but no other value that you use on that particular painting will be any darker. This way you can decide whether your painting is going to be in a high key or a low key — just as you can play a melody on the top half of the piano keyboard or on the bottom half.

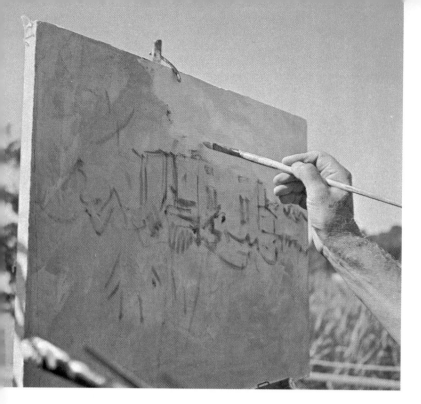

Here, in the sky area, I'm working thalo blue mixed with white into the wet underpainting of white and yellow ochre.

"In view of the fact that value is distinct from color; a blue or a green, or any other color, can be dark in value or light in value depending on illumination and on the values of the things surrounding it. Even a yellow, which is ordinarily a light color, can be dark in value if it's in shadow. Of course there are some colors that are characteristically dark and can only be made light by adding so much white that they virtually become other colors. Burnt umber would be an example, and some of the reds.

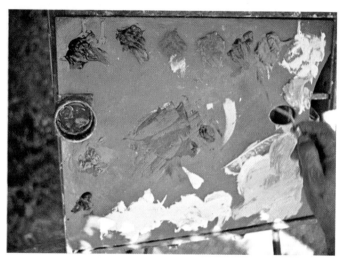

My palette — cadmium yellow light; yellow ochre; cadmium orange; cadmium red light; burnt sienna; burnt umber; cerulean blue; thalo blue; and white. I also mix batches of color for large areas such as the sky and foreground grass.

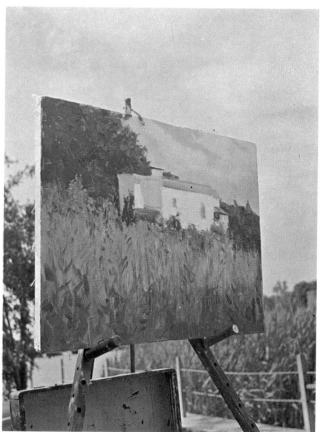

The grass in the foreground is interesting enough to be a painting in itself, but it must not detract from the center of interest, which is the house, so I treat it very broadly.

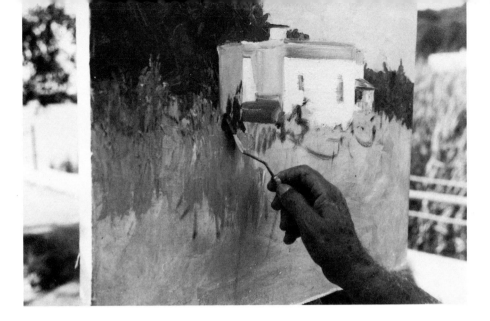

The palette knife not only helps cover the canvas rapidly but is indispensable in getting textures and a variety of surface effects.

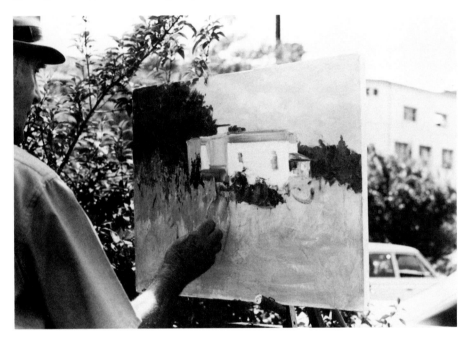

It's important to avoid getting involved in the representation of things as things rather than as shapes and values.

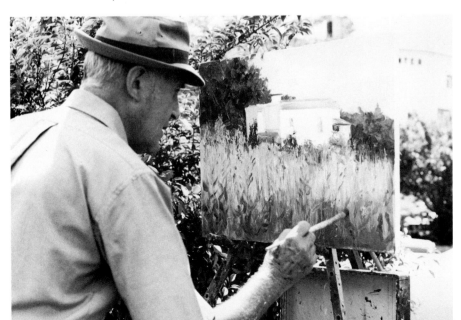

77

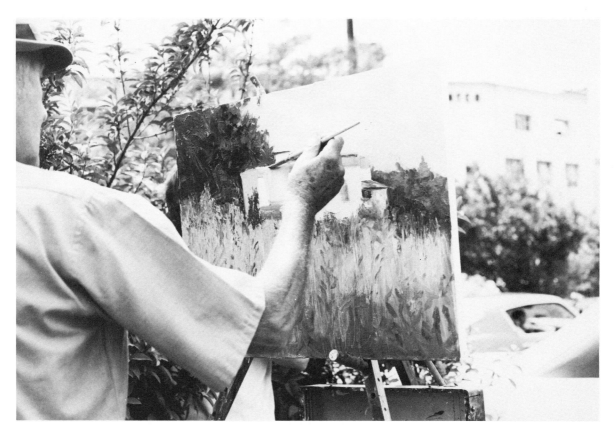

As I paint I am also continually drawing with the brush.

The wrong end of the brush is a good tool for scratching and creating textures.

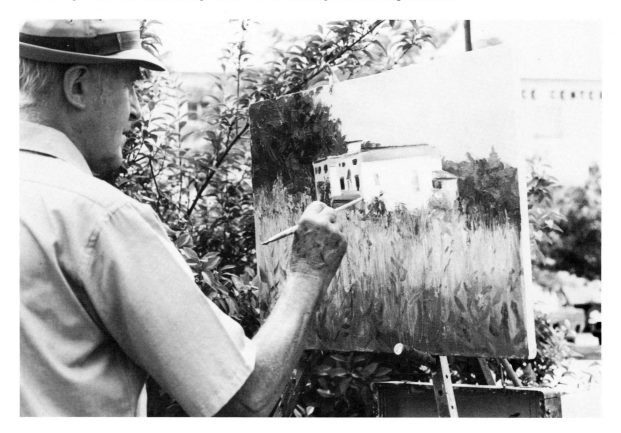

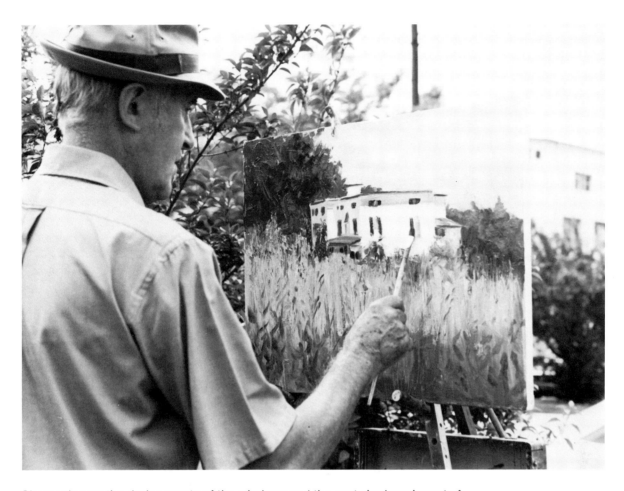

Sharpening up the dark accents of the windows and the cast shadows is part of the finishing process.

"Half of my canvas in this painting is foreground, consisting of a screen of tall marsh reeds that partially hide the house. If I look closely at these reeds I can see a tremendous amount of detail. I could make a beautiful study of a close-up of those grasses. But the foreground should be kept simple so as not to distract from the center of interest, which is the house. After all, it's out there in the middle distance that you ordinarily look when you view a landscape. You can't look down at the foreground and up at the center of interest at one and the same time. One focal point is the rule. Don't try to say two things in one picture.

"So I treat the foreground broadly, almost impressionistically. The palette knife is very useful for these broad effects. Also the end of the brush handle makes a good tool for scratching in the wet paint and suggesting textures.

"As you work let the brush strokes show, just as you put them down. In other words, don't try to smooth out the brush marks. Let them be. They're the handwriting of the artist.

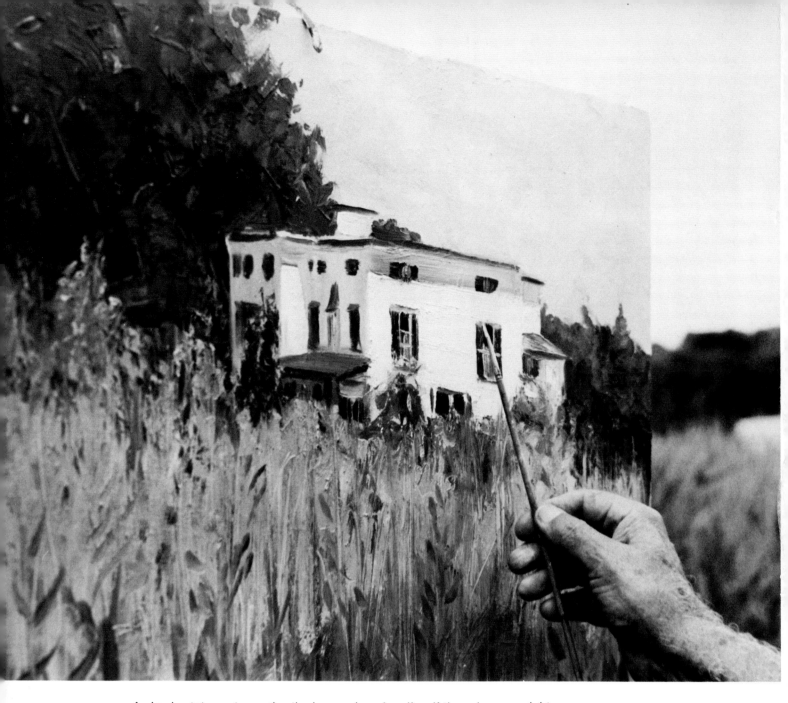

A simple statement can give the impression of realism if the values are right.

"A very simple statement in paint can convey the impression of realism if the values are right. I believe it's important to avoid getting involved in the representation of things as things rather than as shapes and values. It is these tonally related shapes that are important, otherwise you get bogged down in trying to render details, and each part of the picture becomes a little separate project and you're in danger of losing the all-over unity, the wholeness and oneness of a well organized picture.

"Details should be suggested, not copied. The important thing is to get the character of the subject. The oldness of an old house can be interpreted in the drawing and the textures. An old house isn't as neat and four-square as a new one, it's not as slick, and so you take these features into consideration as you paint.

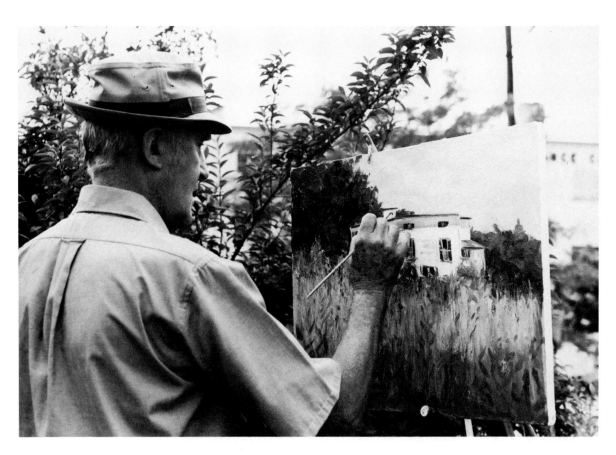

Details should be suggested, not copied. Otherwise each part of the picture will be a separate project and the unity will be lost.

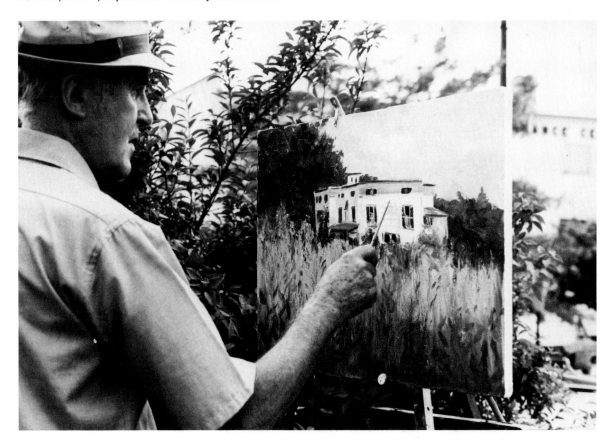

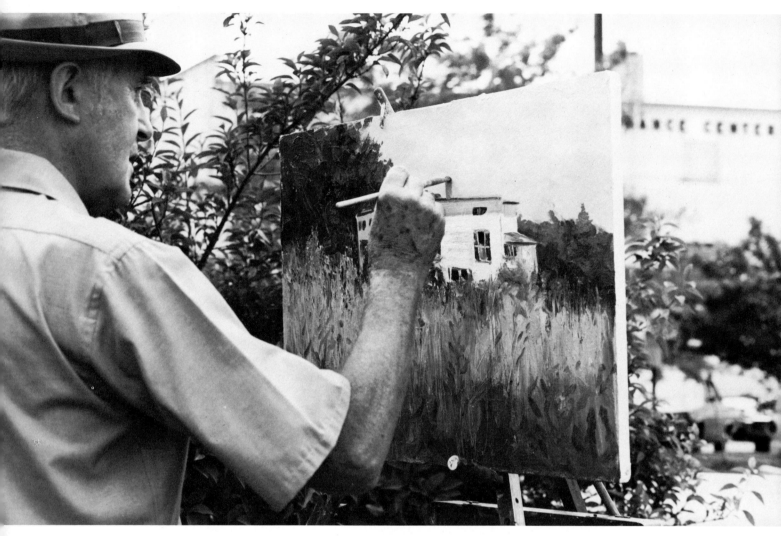

Details such as the chimney are painted last. The brush, if loaded with paint, will readily cover the thinner layer of wet paint in the sky area beneath.

"Several times during a painting session I clean off my palette and replenish it. Again I add a little medium to each of the newly squeezed out colors in order to keep the mixture the same throughout. For cleaning my brushes I use kerosene. It's not as hard on them as turpentine and it's cheaper.

"The light constantly changes as you work, so I suggest you work fast. But even so, the shapes and positions of the shadows are different from one half hour to the next. Under these conditions you must try to stay with your initial impression and interpretation of the scene. If you don't your painting will be full of contradictions.

82

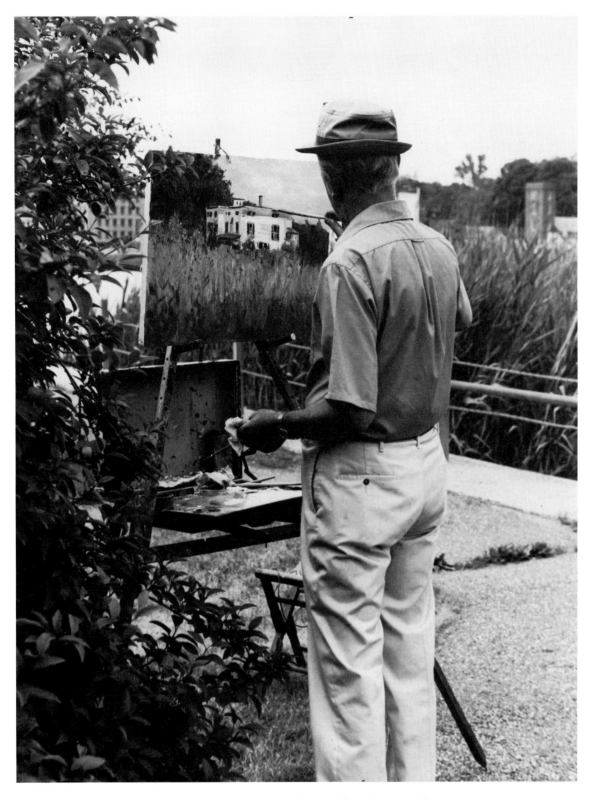

Cast shadows are illuminated by a great deal of reflected light. Be careful not to get them too dark.

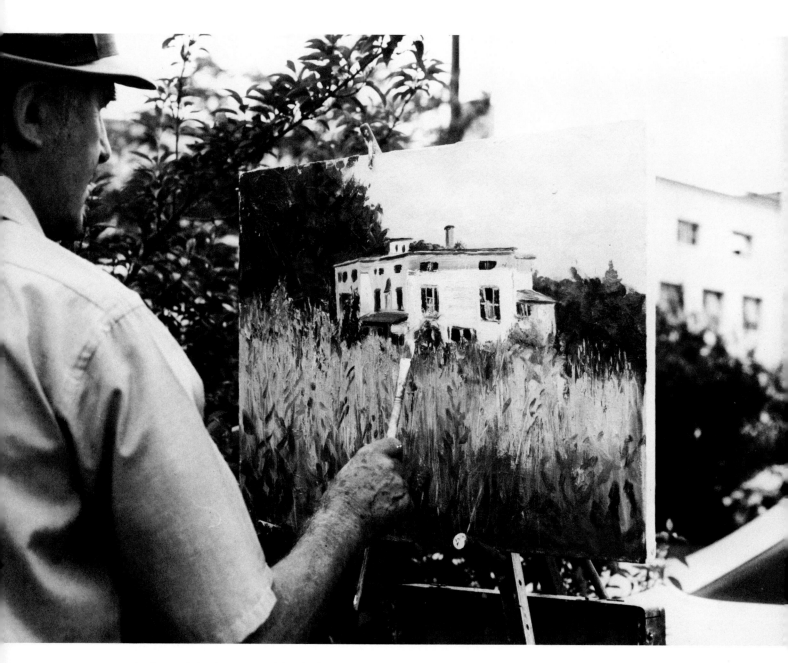

In the end the important thing is the character of the old house, as interpreted in the loose, sketchy drawing, the somewhat impressionistic treatment and the textures.

84

"Finishing the painting is a matter of sharpening up the shapes of the dark accents in the windows and the cast shadows of the house. Shadows are always dark, but out-of-doors they get a great deal of reflected light. Monet once said something to the effect that the most important person in the picture is the light. True enough, but without shadows to emphasize the light, that importance would not be realized.

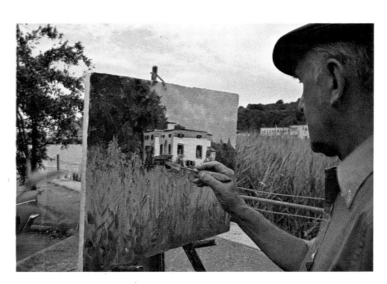

Right. A painting knife can be used to remove paint as well as to apply it.

The completed painting.

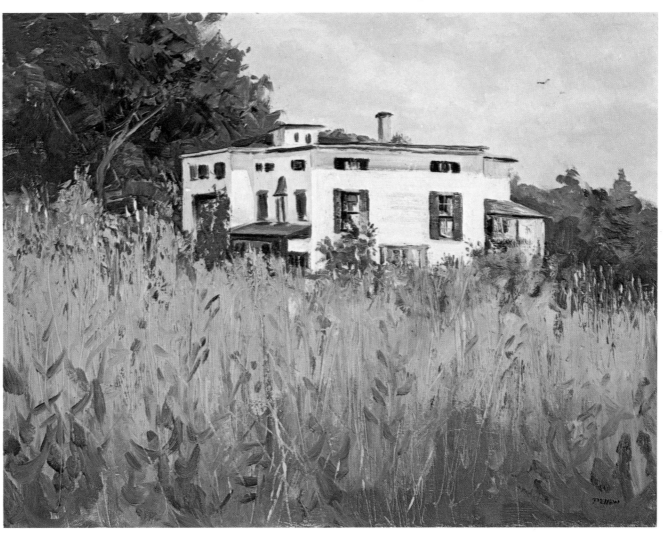

5 HANS WALLEEN

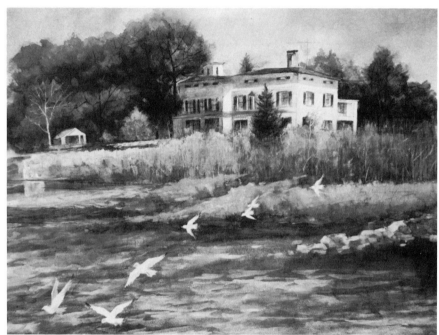

The artist in his studio.

The finished painting.

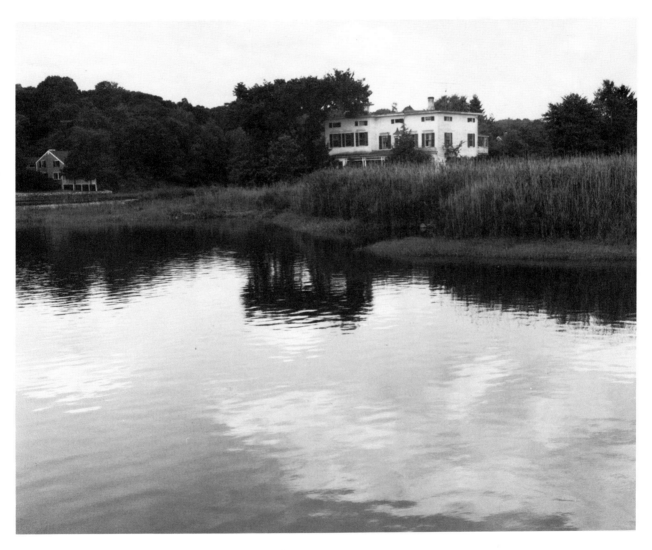

The point of view from which he made his painting.

Ordinarily, when I'm
painting a landscape, I
don't make a pencil drawing
on the watercolor paper.
Architecture, however, calls
for a certain precision,
so here I've indicated
the lines of the house.

A cushion to sit on, my palette, brushes, paper,
paints and plenty of water and I'm ready
to begin. I don't set a palette in any formal way.
Usually I just squeeze out the colors I need
as I go along.

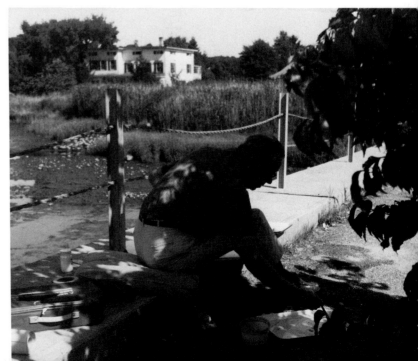

Hans Walleen was brought to the United States from his native Sweden when he was a small boy. He vividly remembers the skyrockets that greeted the ship as it steamed into New York harbor. How were he and his mother to know that it was customary to celebrate Labor Day with fireworks at Coney Island? They quite naturally assumed that the display was in honor of the landing of the Walleens.

Shortly after graduating from Pratt Institute, Hans took a letter of introduction to the studio of Charles Dana Gibson, then one of the most popular illustrators in America. Gibson not only encouraged the young beginner but introduced him to the editors of (the old) *Life,* for which publication he subsequently drew many cartoons.

As a freelance artist he did posters for Thomas Cook and Son, the Red Cross, and the Salvation Army as well as numerous other clients. In 1933 he designed the Christmas seal for the National Tuberculosis Association. For several years he taught advertising layout at Pratt Institute.

During a long association with the William Esty Agency he designed and executed the art for many national advertising accounts.

He is an associate member of the National Academy of Design and an Honorary Life Member of Allied Artists of America. For two years he officiated as president of the American Watercolor Society — an office he resigned when he retired from the New York arena to live, paint and teach in Connecticut.

At the same time he relinquished membership in the Society of Illustrators and the Salamagundi Club. "I miss all that," he says of the fellowship and conviviality of those organizations, "but I've quite made up for it by the inspiring companionship in the Fairfield Watercolor Group."

Today he divides his time between painting and teaching. He takes as much pleasure from the success of his talented students as he does from painting and exhibiting his own prize-winning watercolors.

"This old house that has apparently lost its elegance and former glory conveys a sense of history. It stands alone on an island in the Saugatuck river only a hundred yards or so from busy Main Street, with the stores, the delivery trucks, the parked cars and the people intent on their shopping. The contrast emphasizes a feeling of continuity — of history.

"I studied the house and its setting before undertaking to paint it. I made a quick pencil sketch, marked with notes to suggest which features to develop, which to subdue or leave out. It's important to make these decisions early.

"When it came to sitting down on the spot and beginning the painting, the only preparatory pencil drawing on the water-color paper involved the architecture of the house. Ordinarily in painting a landscape, I don't do any drawing beforehand. It's more fun to invent as you go along.

"This is something I sometimes go into with my students. They draw so completely and then, when they begin painting, they often think they have to fill in everything accurately up to the lines. I let them do it this way when they're first learning. They need the discipline. But after a while I encourage them to begin painting without the drawing. After all, who's going to check on the rocks and trees to see how big or how small they really are?

"Simplicity, pattern, variety, mood — these, it seems to me, are four words that should be kept in mind by anyone who tackles the challenging medium of watercolor. Variety, especially, is a key word in my vocabulary — variety of subject, variety of tone, variety of texture.

"It seems to be customary with many landscape painters to begin with the sky, if there's to be a sky. The way the sky is treated, the colors used, often determines the color and mood that suffuses the picture as a whole.

"The time I've chosen to begin my painting is the morning of a beautiful summer day. The sky is clear cloudless blue. But from a painting point of view it's not an interesting sky. It's not entertaining enough. It doesn't have the variety I like. So I have to invent.

"First, a soft wash of cadmium yellow pale painted over the entire sky portion with a wide flat brush and plenty of water. Then, while it's still wet, I float some blue into it here and there and just a touch of red which runs with the blue to make a subtle violet.

"Out of doors the light constantly changes, especially on a sunny day. And here, as is often the case, spectacular and bewildering changes begin to take place as I work. Great cumulus clouds float across the blue sky. A wind comes up. The tide pushes in, covering the mud flats in the river bed.

"Now decisions must be made, and there can be no hesitation. The important thing is to put color down on paper — to cover the whole sheet with a little of this and a little of that. These initial washes will fade as they dry and become very subtle. At this early stage it might look as though I'm a pastel painter, but actually what I'm doing is an underpainting of large flat areas that establish the approximate value and color relationships over the entire surface. In the end I'll develop these suggested tones and colors into strong contrasts of light and dark.

"You can paint into an area when it's very wet or over it when it's entirely dry, depending on the effects you're after. But there's an in-between point when the paper's not completely dry, and if you drop wet watercolor on it the paint will begin to dry as it spreads and form sharp edges around itself instead of blending with the under color. Here, in the underpainting, it's not going to matter too much because I'll be going over it with darker tones, but I think the best way to work with watercolor is to paint freely while the paper is good and wet, or else wait until it's completely dry before adding more washes.

"The palette. We were advised in school to set a sequence of warm to cool colors around the rim of our tray. A good idea probably, but it doesn't work for me. In a few minutes, chaos. So I squeeze out pigment as needed on a clean spot or where there's been something of the same. So-called "dirty" color isn't necessarily bad. It's a result of painting that's been going on and may well relate to the rest.

"These are the colors I find most useful: cadmium yellow pale; cadmium orange; a bright red — scarlet lake; a deep red — alizarin crimson. Two greens, viridian and Hooker's green dark. Burnt umber, burnt and raw sienna. One blue only, Prussian, which an eminent painter has said retains its vibrancy especially well under artificial light. And indispensable to me in itself and as a modifier is Payne's gray. The next artist you talk to or read about will have his own array. We have all seen many fine paintings in which very few colors were used. A not-always thorough blending of these is likely to produce spontaneous and happily varied effects.

"And white. I use white without feeling guilty at all. There are many watercolor painters who wouldn't think of using white. They believe there's something a little bit mischievous about that, as though it weren't quite honest. However, I do usually keep and mix the white in a separate container rather than put it on the palette because I don't want it accidentally mixing with the other colors.

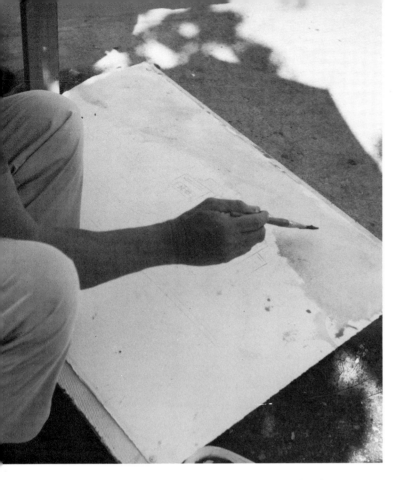

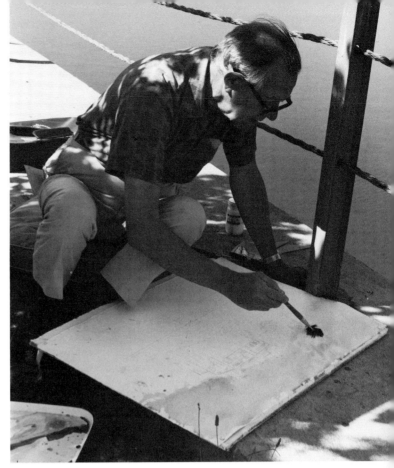

It's customary with many painters to begin a landscape by laying in the sky.

The sky is blue, but to give it variety and interest I begin with a yellow wash into which I float blue and a little red. Here and there I blot up some of the excess moisture with a paper towel or a sponge.

The way the sky is treated, and particularly the colors used, often sets the tone for the rest of the painting.

While the sky is taking a little time to dry I keep away from it and work on the lower part of the paper.

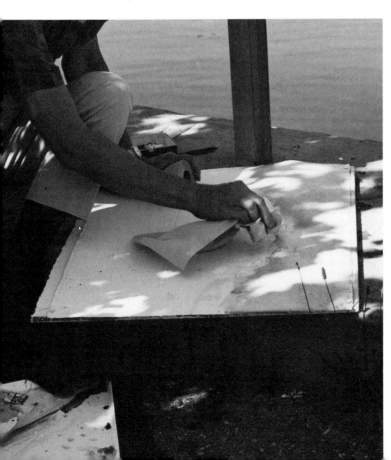

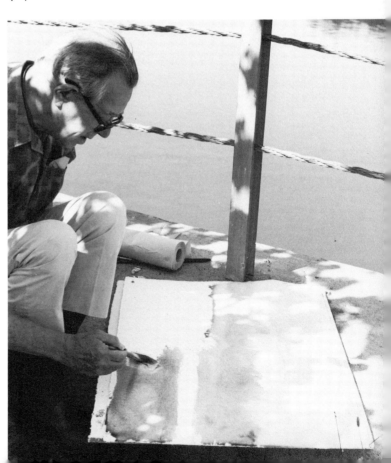

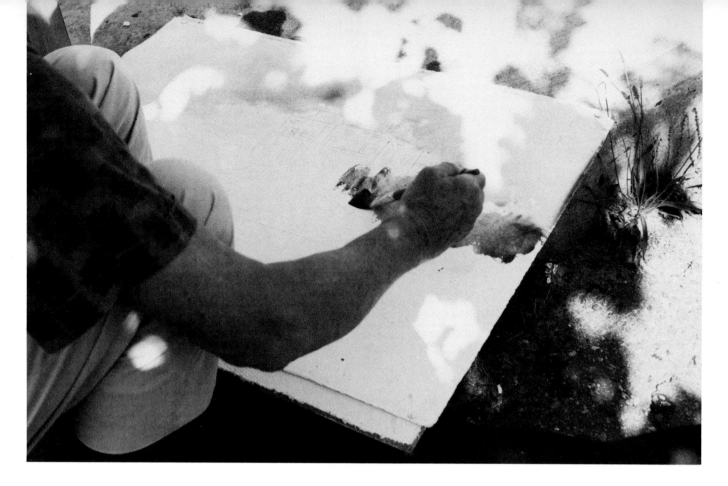

The important thing is to get the whole paper covered with color.

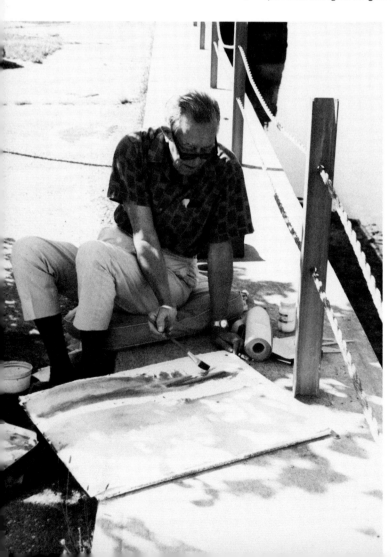

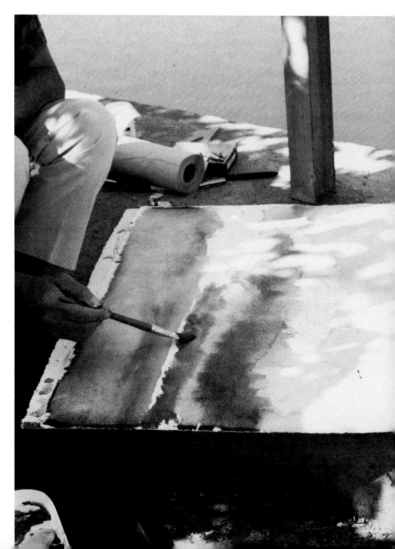

"I don't dare begin painting the trees around the house while the sky is still wet because the greens will bleed into the sky area more than is desirable. So I move down to the lower part of the picture for the time being. Where the water's coming in with the tide, rising against the mud and rocks of the bank, I put in some umber and build a certain kind of green with a mixture of Payne's gray and orange. Sometimes I work the wet paint around on the surface of the paper with my fingers. Back to my childhood with the finger painting.

"I don't often use sponges, but in this instance a sponge is helpful to blot up the excessive moisture in the sky so I can get on with the green foliage in the central portion of the painting. As I brush on these green washes I paint around the house, cutting in the sharp edges of its outlines. Edges, I feel, are very important. Straight or jagged, hard or soft, they help describe the character of a thing. I won't do much work on the house itself, however, until near the end. Now what I'm still working for is to get the whole sheet of paper covered.

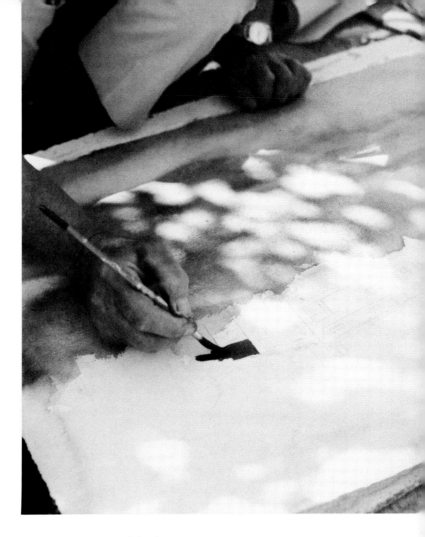

As I brush in the first green of the foliage I am also defining the shape of the house. Edges are very important. They help describe the character of things.

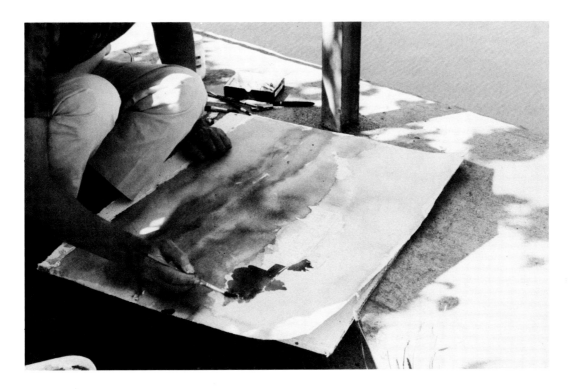

93

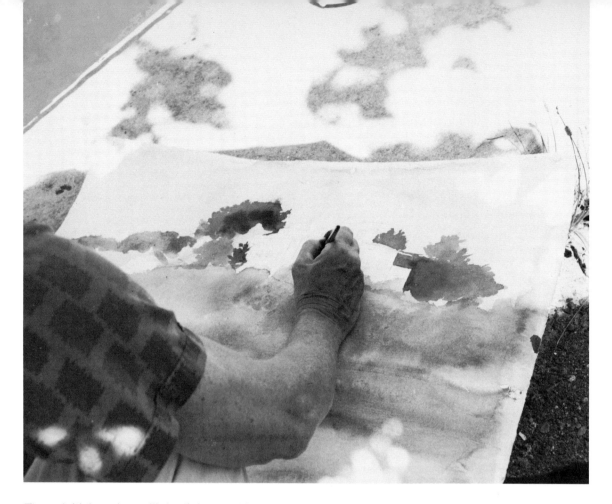

These initial washes will dry lighter and become an underpainting. At this stage they just begin to suggest the approximate value and color relationships over the entire surface.

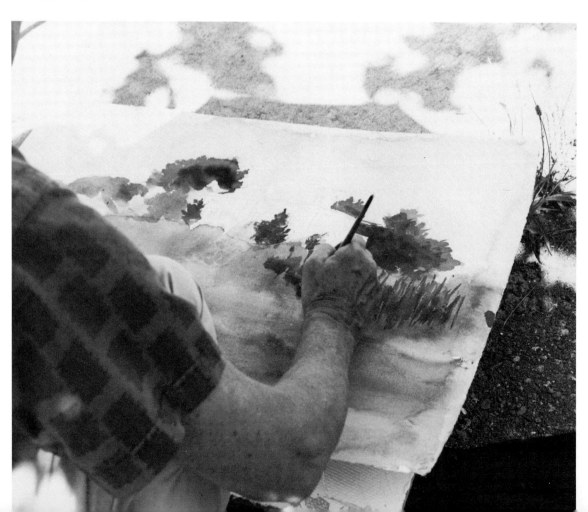

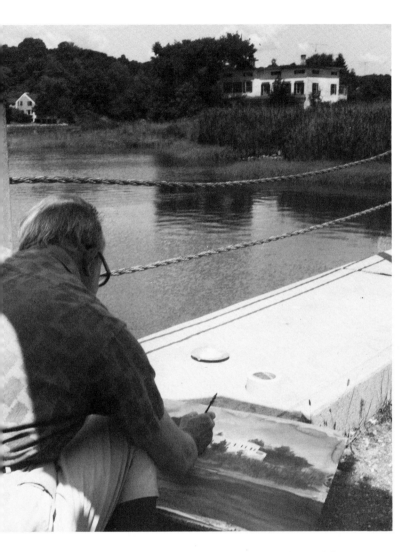

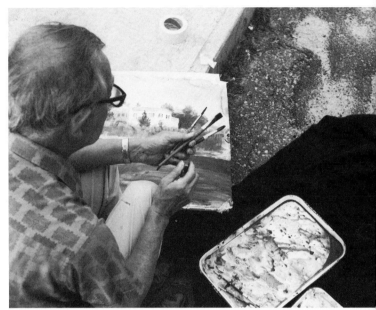

Not too much detail in the house —
just enough to suggest its most
characteristic features.

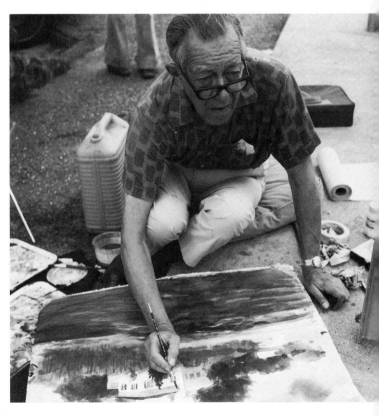

As I develop the values and colors with
successive washes they gradually build in
strength and contrast.

"Building up — building gradually — that's
the idea. In places that may be getting dark in
value before I want them to, such as the water
in the foreground, I paint on white to lift it up,
to brighten it. When the white's more or less
dry, I scrub new washes of color over it so
that the white mixes somewhat with the new
wash right there on the surface of the paper.
It's a back-and-forth process that keeps me
in control while I'm building up the values
and colors of the overall pattern.

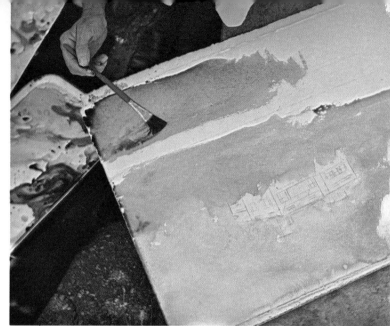

I mix the soft mossy green of the river's edge by combining Payne's gray and orange.

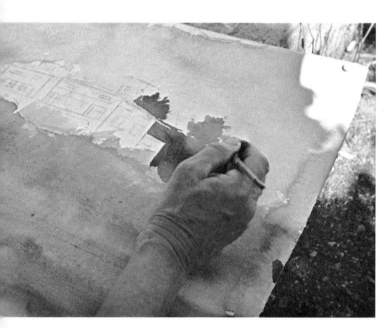
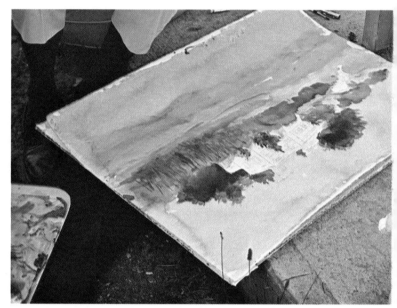

I wait until the paper is dry before painting the foliage around the house.

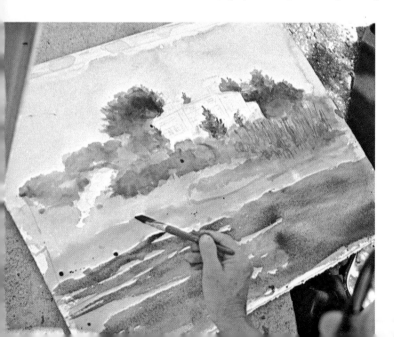
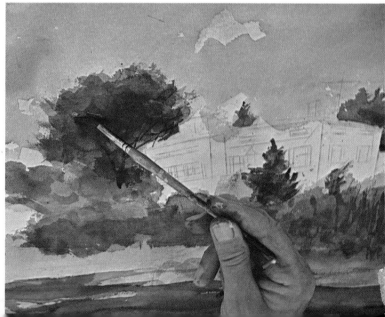

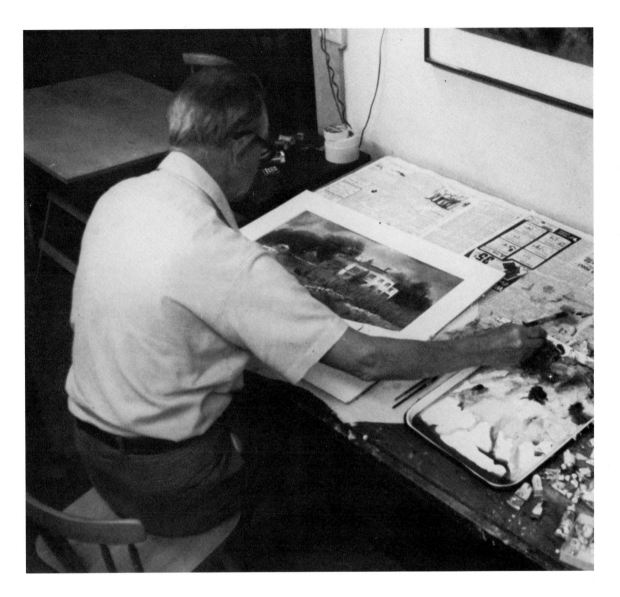

"Probably ninety percent of all paintings
begun outdoors are finished in the studio.
I can usually complete a painting like this in
about three hours. But sitting on the ground
isn't very comfortable. There comes a time
when I like to sit and contemplate what I'm
doing, think about it as I pull it all together.
I'm ordinarily very loose and free in my
painting, but the house is an exacting
challenge that demands time and concen-
tration and I prefer doing it indoors.

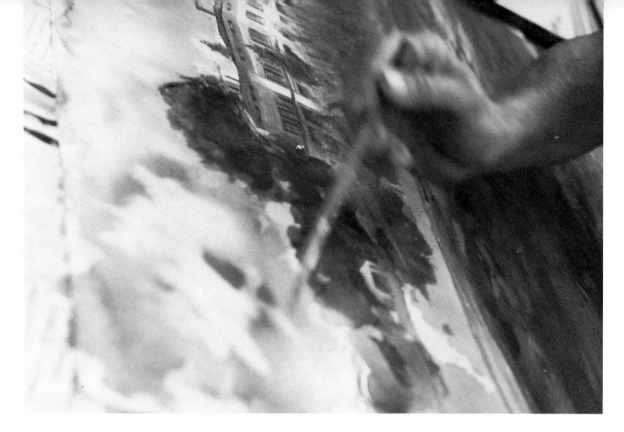

I rewet the sky with clear water before working back into it so the overpainting will blend without hard edges.

Vertical streaks of opaque suggest the texture of the tall grass in front of the house.

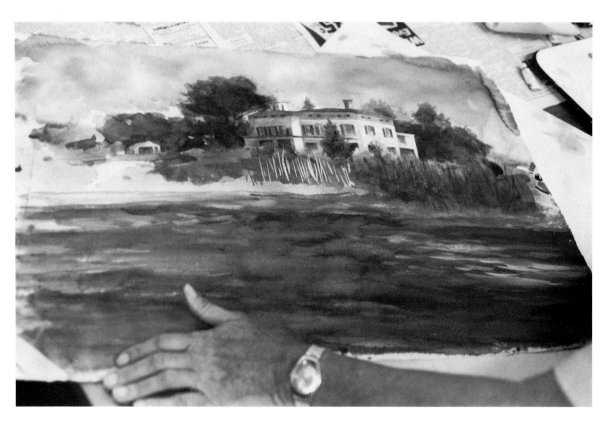

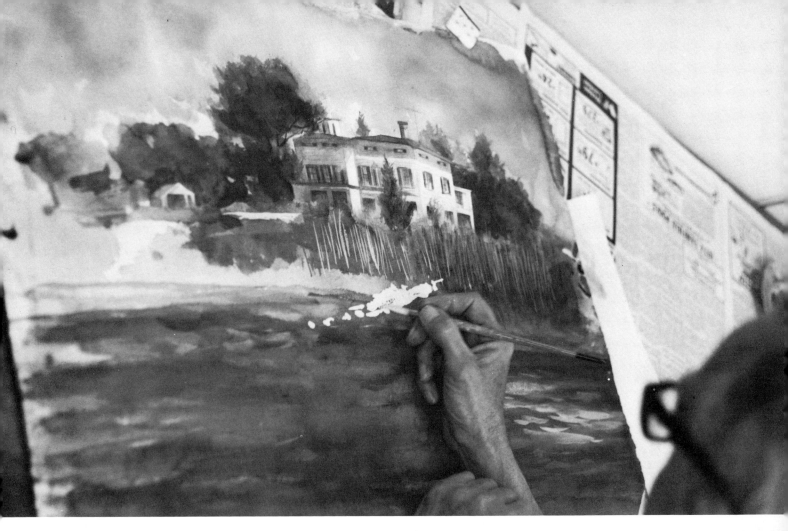

I use white freely, without feeling guilty at all.

Where any part of the painting gets darker than I think it should be, I overpaint with white. When the white is more or less dry I scrub new washes of color over it.

"It's an old and broken-down house, but for all that it has the integrity of a solid architectural structure. It is composed of verticals and horizontals and a certain amount of detail. To be sure, I don't put in too many details, but just enough to give the right color and character — the windows, a suggestion of the board siding, and so on. This takes almost as much work and time as I've given, so far, to the rest of the painting.

"Once the house is done, the finishing is easy. That's where the fun comes in. I study the values and make changes where necessary. I try to keep simplifying and at the same time to produce variety and interest.

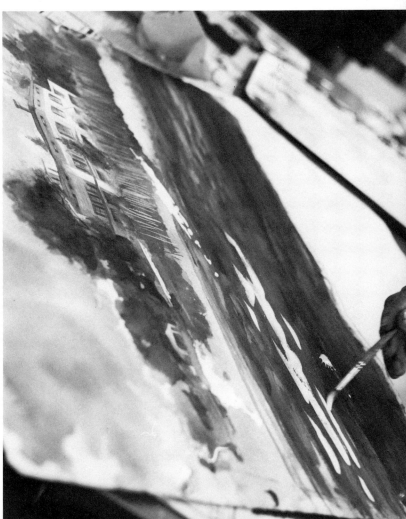

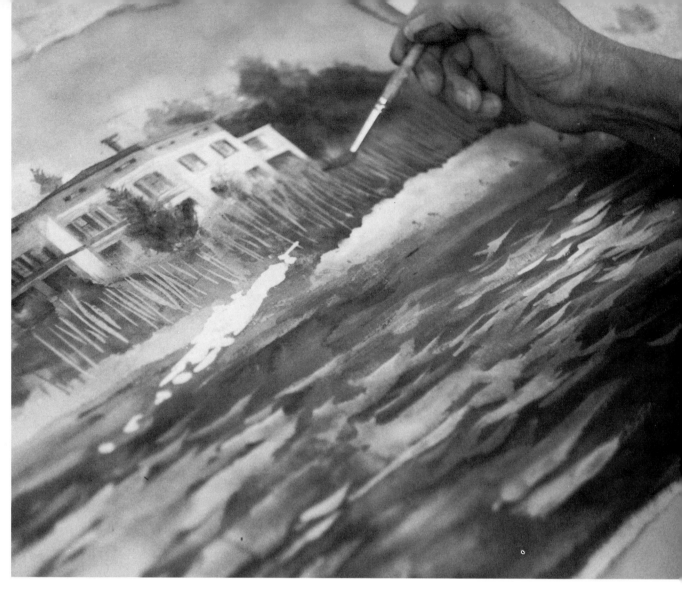

To build up the foreground rocks, I first lay down an area of white.

"Another spot where the white helps, is in the trees just to the left of the house. I'd like their dark branches to show in among the heavy summer verdure; but if I paint them now, using burnt umber, I'll be putting dark on dark, burnt umber on green, and the result won't read clearly enough. So when the green of the tree foliage has dried sufficiently, I paint over a section of it with white. As soon as that's dry I use a small brush to delineate the branches. Now the burnt umber stands out sharply on the white. Of course I don't try to copy them exactly as they are. I suggest their characteristics — the way they finger out delicately to their slim extremities, never parallel, with many crooks and turns.

100

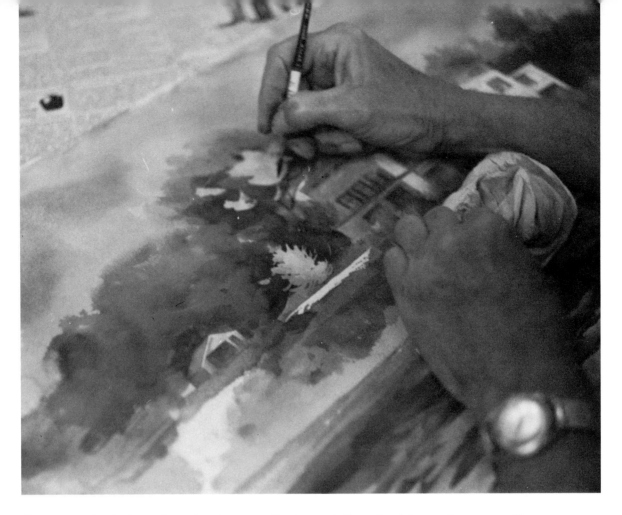

To suggest the dark tree branches in among the heavy foliage, I paint over the green with opaque white. As soon as the white is dry I put in the branches with burnt umber and a small brush. Then I paint on more green washes to cover the white and soften the whole effect.

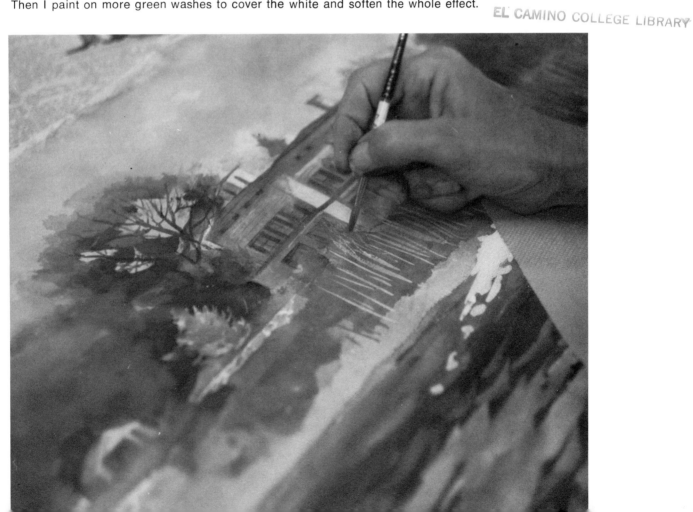

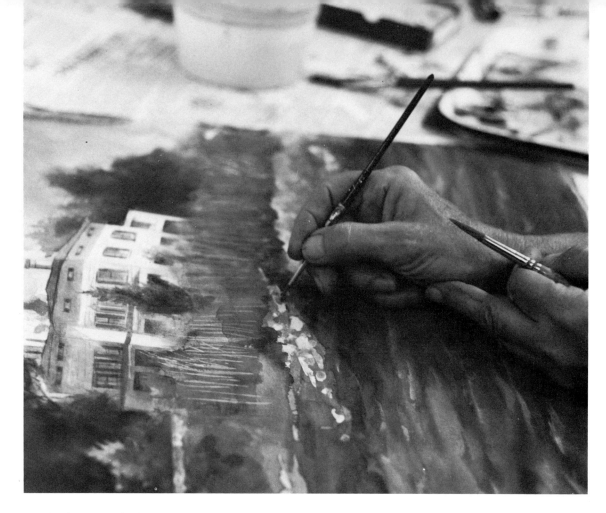

I paint in the rock shapes.

A deeper, stronger blue seems needed here. I can always soften it later if necessary.

I have to be careful to avoid too much detail that will make the painting seem fussy or busy.

"Once the dark branches have been painted over the white, I begin brushing new washes of green over that area, scumbling it on, rolling the brush around, so that the green blends with the white and the entire effect of foliage and branches becomes unified.

"Sharpening the delineation of the rocks emphasizes their textural differences. There is a danger in getting too busy with too much detail, but if that starts to happen I can always wash over it with water to tone it down and pull it together.

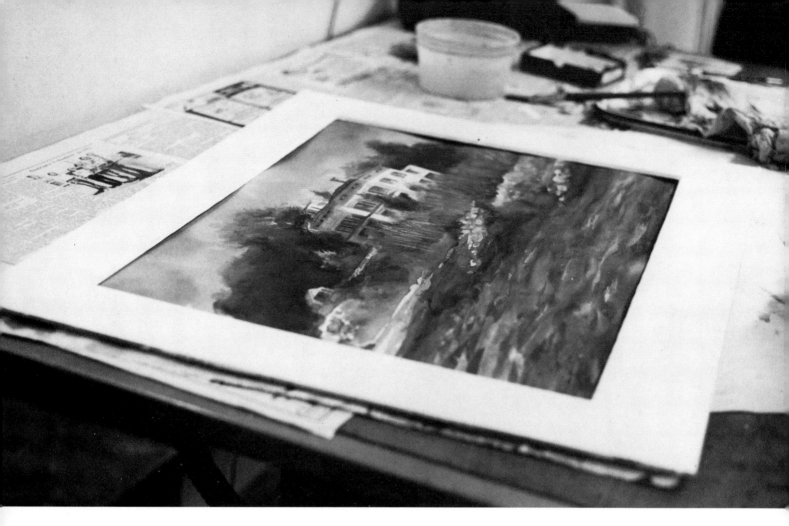

A white mat, with an opening smaller than the over-all size of the paper, masks out the rough, unfinished edges.

"The closing stages are always absorbing to me. The word "lose" bounces off the walls often on class days. Lose emphasis in places that have been fighting too much for attention. Throw light on an overly modest place. See that some of the rocks retain their cragginess. Bring all together in sympathy.

"Everything has been fun, but this stage is the most enjoyable. Send some gulls scooting across the foreground. Their color will repeat the white of the house — balance the pattern. The big diagonal movement of their flight gives life and action to the finished picture.

"A white mat with an opening smaller than the full size of the paper enables me to mask out the rough unfinished places around the edges and to make adjustments in the composition by cutting down the foreground and part of the sky, thus giving more importance to the house at the center of the painting.

"At the end I use a pen with a fine point, and ink, for a few accents. I just kiss the paper very lightly so that you're hardly aware that I've made a mark. This is for crispness and finish.

"It is a lifting experience if one can look back at a painting and say, 'This is about the best I can do.' When I come close it's a nifty feeling.

"A parody of Cole Porter song to finish us off:

> Have you *ever* felt the spell of aquarelle?
> Have you *ever* had a crush on a sable
> brush?
> It's blendship, blendship,
> Just a perfect friendship —
> Other mediums attract me some,
> But *this* — it's *maximum!*"

104

Overpainting with the opaque white looks drastic at first, but it can be easily blended into the underlying color with controlled amounts of water. Fingers, too, are useful in assisting the blending.

The gulls, added at the last, provide the finishing touches.

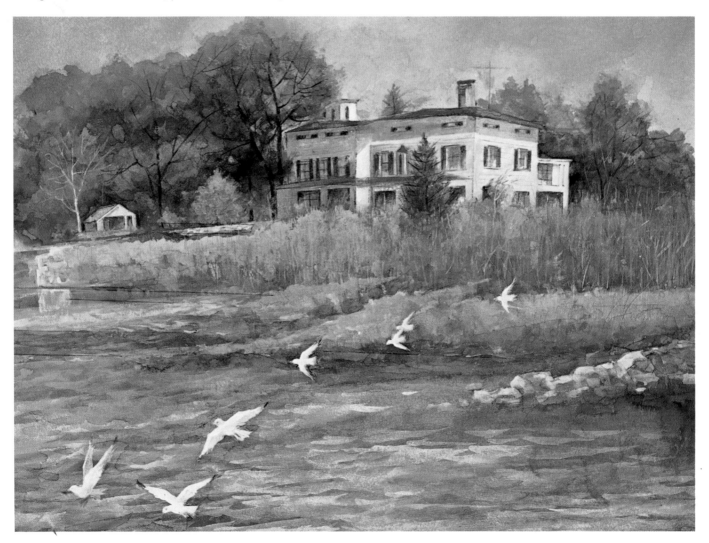

6 ALEXANDER ROSS

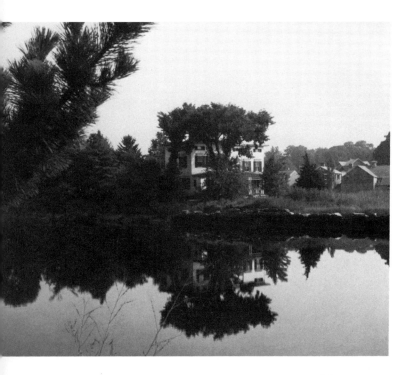

The scene. The artist.

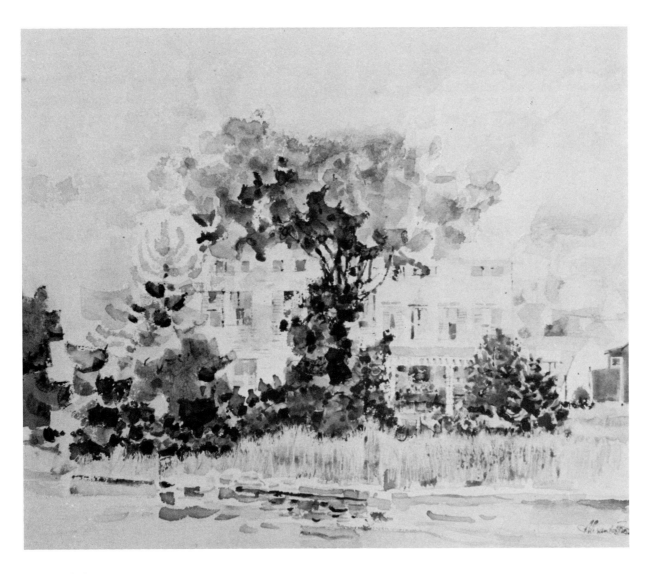

The painting.

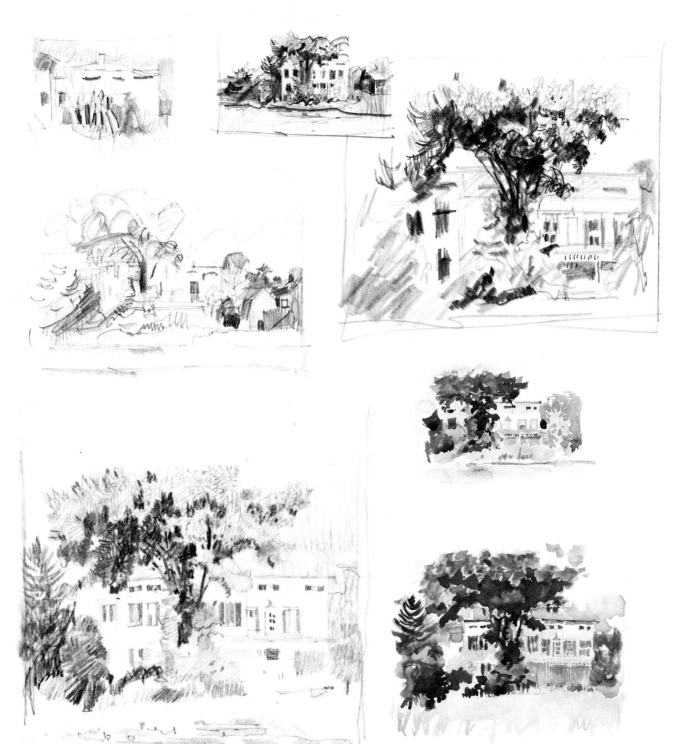

In my preliminary pencil sketches I found myself focusing on the tree and the big foliage shapes as the central theme of my picture concept.

I visualized bright autumn colors. The more I developed these color sketches the more the house became subordinate to the great mushrooming tree.

There are landscapes that occur in dreams, formed and colored as much by subconscious processes as by objective logic; nurtured in fantasy; translated from what any observing eye can see to what only a poetic imagination knows. Such are the landscapes of Alex Ross.

Not every artist can clearly foresee, as he begins a painting, how it will ultimately look. Nor does he necessarily know, after it's finished, exactly how it came about. The more sensitive and imaginative a work of art, the less easy it is to explain in terms of how-to-do.

An all too seldomly recognized fact concerning artists, however, is that not infrequently one embodies the visionary and the practical in a single surprisingly effective entity. Certainly this is true of Alex Ross. Perhaps his Scottish origin accounts for the practical side of the equation. Be that as it may, the evidence is a spectacularly successful career as an illustrator, in which he has distinguished himself for the same kind of creativity and originality that characterize his present painting.

His colorful landscapes are enchanting escape lands. He paints what he pleases — and thereby pleases so many others that he is as busy fulfilling the demands of collectors and meeting exhibition schedules as he ever was satisfying art directors and complying with publication deadlines.

In addition to having done work for America's foremost publications and industries since 1935 he has been winner of awards in national and regional exhibitions from coast to coast. His paintings are in numerous museum and private collections. He is a member of the National Academy of Design; American Watercolor Society; Connecticut Watercolor Society; Silvermine Guild of Artists; Connecticut Academy of Fine Arts; and the Fairfield Watercolor Group.

"I don't ordinarily work directly from nature. I'm not really interested in capturing every little detail of the scene I'm painting or in making it as realistic as possible. Not that I have any quarrel with that kind of approach. It's just that I'd rather give it my own treatment, in which I like to blend the reality of nature with the unreality of a fanciful world of my own imagining. My usual way is to observe nature and then work from imagination. Consequently I paint almost entirely in my studio.

"I have great respect for the school of art that goes beyond literal representation of the natural world. It demands that the artist *must* be creative. At the same time I don't want to go on record as lacking respect and admiration for artists who are intelligent and highly-skilled craftsmen regardless of what school or style they work in.

"In studying this subject and thinking about it before I began to work, I asked myself what I could do to make it personal, to make it my own statement. I found my attention focusing on the huge tree that mushrooms over the white house. Its mass of foliage forms a big, dominating shape. It struck me that it offered a great opportunity to express, through a build-up of exciting color and strong pattern, both the reality and unreality of my concept.

I squeeze out colors as I need them rather than setting up a full palette.

I keep the board flat on the work table, tilting it only when I want the wet paint to run.

"So my approach was to move in and try to make the most of the tree in a colorful, abstract way, rather than doing a meticulous, realistic sort of thing. When I look at a tree I'm not thinking of the shape of each little leaf or worrying whether it's an elm or a maple. I'm seeing directional lines and curves that lead from one form to another and that perhaps repeat themselves to suggest motifs and rhythms. I'm thinking in terms of line and mass and design. In this planning stage I visualize that tree as a broadly built-up mass, with bright autumnal coloring, and the house almost as an incidental thing back there, its architecture just suggested, without any hard, tight quality to it.

"I try to introduce into my paintings this arrangement of shapes that is primarily abstract and only after that has meaning from the representational point of view, rather than the opposite. In other words, my emphasis from the beginning is on abstract design.

"Such is my approach and on the basis of it, working from a combination of memory, imagination, and knowledge of my craft, I make a small preliminary color sketch. The execution of the painting is largely based on this sketch.

"I work on a board that's especially prepared for me by an artists' supply establishment. The surface is gesso, but it's different from an ordinary gesso ground because it contains a chemical that gives it a tendency to reject the water based acrylic pigments with which I paint — or, to be more precise, it rejects water itself.

"There are advantages and disadvantages to working on such a surface, but what most artists might call a disadvantage — namely the fact that it won't behave like an ordinary material such as watercolor paper — I consider an advantage. As I put on paint it stays on the surface. It puddles and crawls almost as though you tried to paint with watercolor on hard enamel. Unlike watercolor papers there's very little absorption.

"This pleases me because it's constantly resulting in unusual effects. Interesting accidents happen. Things keep getting in the painting that aren't planned. I have to stay on

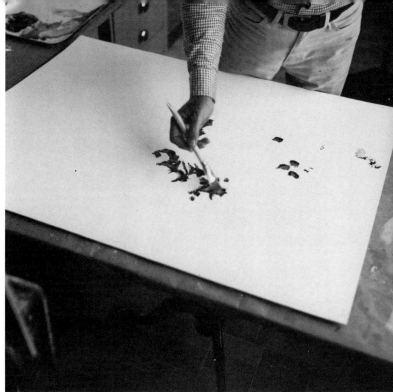

A few very light lines made with a pastel crayon, not even visible in the photo, is all the drawing I do on the board before beginning to paint.

My painting surface is a specially prepared non-absorbent board. The tendancy of the ground to resist the paint I put on it is an important part of my technique.

guard for the unexpected and make use of it when it occurs.

"It's a very tricky business and a lot of artists would say it's impossible. But it suits my temperament. I like the excitement of constantly making new discoveries. There's always a surprise waiting around the corner. Sometimes it can be a disappointment. But I depend on mistakes. Good and bad things happen all the time.

"I must point out, however, that in working on this surface I'm not entirely at the mercy of an uncontrollable series of accidents no matter how much I depend on them happening. I can neutralize the resist character of the ground at any point by applying a solution consisting of a few drops of photo-flo — a darkroom chemical used in washing photographic negatives — and water. After I've brushed on this solution and allowed it to dry, any acrylic paint that I put on that particular area will adhere more or less smoothly to the ground, much as it would to paper or any other conventional surface.

"Aside from these somewhat unconventional uses of materials I have no prescribed, care-

fully worked-out method. I depend largely on mistakes and blunders and the counter action of correcting them. There's a certain amount of adventure in this. I tackle the unknown, in a way, and I believe that what I do is more creative as a result. I can never safely tell, before a painting's done, what it's going to look like, and I think the process of doing it has to be creative for just this reason.

"I use my acrylics quite transparently, as though they were watercolors. My brushes are both the nylon kind for acrylic and camel hair watercolor brushes, flat and square-tipped. Their type and shape play a role in the way I lay the paint on in many areas — little squarish patches of color, somewhat the way you'd build up a mosaic.

"My palette is not very orthodox. I don't have a formula as to which colors I use, or don't use, or how I arrange them on the palette. The need for a particular color can be an almost spontaneous decision, in which case I pick up a tube and squeeze out what paint I require. The palette can get very messy looking, at which time I wipe it clean and begin afresh.

111

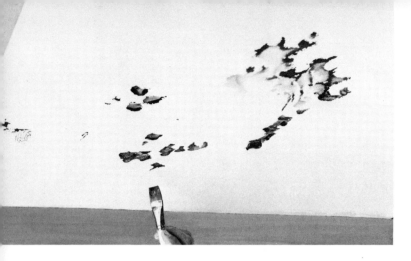

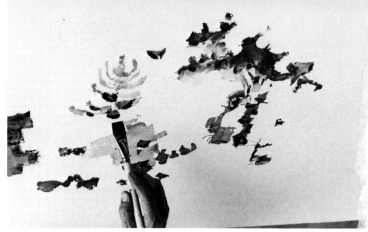

Putting the darks down first gives them time to dry. I can then work lighter, transparent washes over them.

There are a number of ways I can influence and control the paint as I put it on. The most obvious, of course, is with the brush —

— another is by wiping or blotting with a sponge or a piece of paper towel.

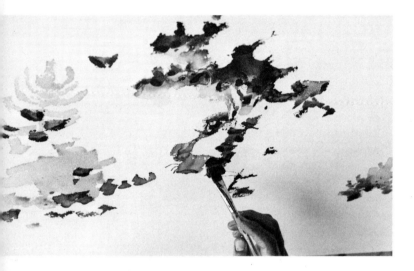

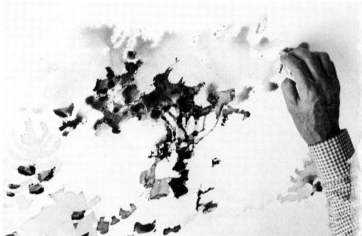

"The first thing that goes on the board, of course, is the drawing. It's very light and minimal. I do it with a pastel crayon, putting it down just to give me some guide lines to follow. I don't fix the drawing in any way because I'd rather not put anything on it that'll interfere with the prepared surface of the board.

"Although I take advantage of the transparency of acrylics, I proceed in an almost opposite way than most painters do with watercolor. Instead of laying in light values and gradually working toward the darker tones I put the darks in first. Because less water is mixed with the pigment the darks dry faster than the lights and so are ready sooner for subsequent overwashes. Putting the dark

areas in first is a further advantage because it establishes a pattern right away. After they're dry I get to the middle tones, and finally the lightest values.

"So, concentrating first on the important dark masses, I begin to paint some key areas. I don't think in terms of drawing and draughtsmanship so much as values, masses and color relationships. Right from the start the color keeps trying to crawl as I apply it. Sometimes I have to tease it into position. As I stroke on each patch of color with the flat straight-edged brush, it seems that I'm going to get a hard edge, but usually that edge becomes irregular and feathery as it dries. I don't like to keep at a thing until it's tired looking, but the beauty of this is that it never

seems to get that way. There's always a fresh look as though I'd painted it entirely spontaneously, even though the spontaneous look I want doesn't come until the tenth try.

"The board has to lie flat on the work table as I paint. Occasionally I tilt it to get certain things to happen. But for the most part I can best achieve what I'm after on a perfectly flat surface where the colors puddle, crawl, spread or flow into each other as they will. When I first worked this way I had to give up sitting down at work, as I always had with watercolor, but now I find that I like standing. It keeps me on my toes and alert.

"The surface and these acrylics behave in such an unorthodox manner that if I were to do the same thing on paper it wouldn't be the same at all. I have to give up any idea that what I start out with is going to remain that way: It just doesn't. I may think, "Oh, there's a great effect — I'll just let it stand." But the first thing I know it's gone. It has moved by itself. I can't make it do everything that I want — but that's part of its charm. I can guide it and work around with it and it still ends up surprising me.

"As the painting progresses the surface becomes more and more isolated by the pigment that covers it. This somewhat reduces its resistant action. So it's necessary to make the most of the special resist effects in the early stages. Later you can get a more normal adhesion and make changes and corrections then.

"I proceed slowly, building up bit-by-bit and thinking it out as I go. Wet areas have to be given time to dry without being disturbed, although sometimes I'll take a rolled piece of paper towel and soak up some of the excess moisture. I don't do this much because the blotting makes a definite pattern of its own, but it's occasionally helpful in breaking up passages that I'd like to keep on the lighter side. Or I might use an electric hair dryer to speed the drying. This is apt to blow the wet paint around on the surface, which is another way to make surprises happen, but if I don't want to disturb what's there I just leave it alone for a while and work on another area.

An electric hair drier can speed the drying process. If it is held near the painting it will move the wet paint around on the surface. This can be done or avoided (by controlling the distance of the drier from the painting) depending on the effect desired.

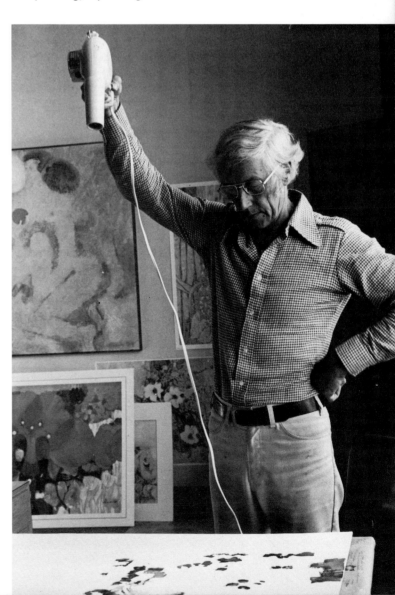

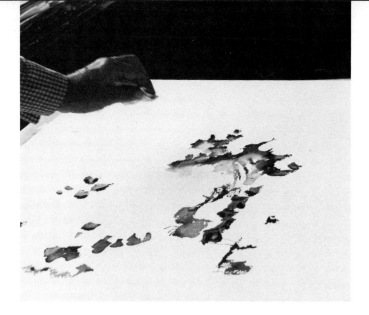
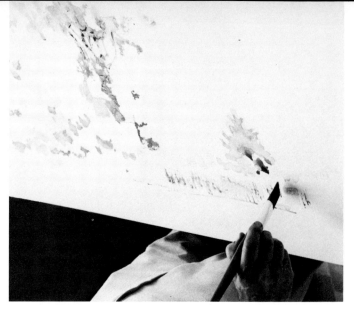

A sponge of paper toweling can be very useful in controlling the amount of moisture as well as adding textural effects. The size, shape and manner of holding the brush can greatly influence the directness and spontaniety of the strokes.

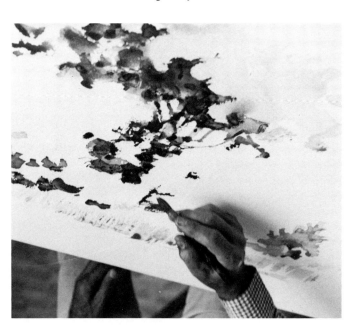
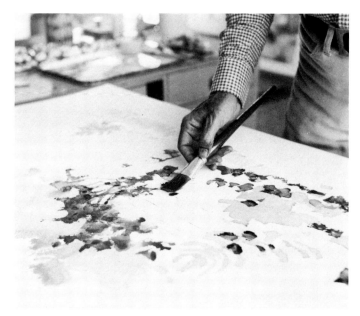

I use both nylon acrylic brushes and camel hair watercolor brushes. Here, the edge of a broad flat brush is just right for indicating the architectural shapes of the windows and porch.

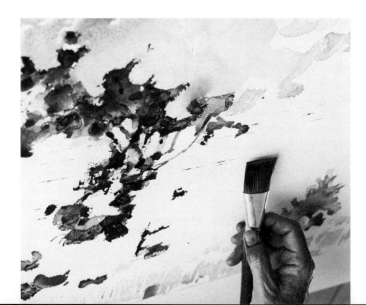
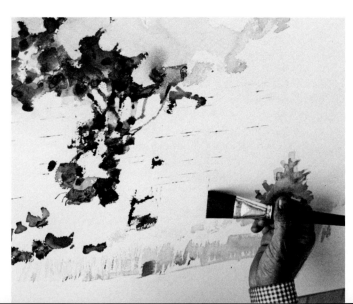

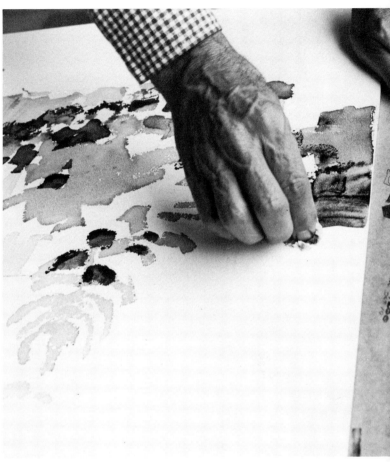

There are several ways paint can be removed from the board when and where desired. One is by applying ordinary kitchen scouring powder to a piece of damp paper towel and gently rubbing out the offending area. Another is by scraping with a knife.

"If I don't like something I've painted I can remove it in any of several ways. I can simply blot it up while still wet with a sponge or paper towel. Or I can rub it off completely with a bit of damp paper towel and ordinary kitchen scouring powder. Or I can scrape with a knife or other sharp tool and bring it right back to white as you would on scratch board.

"In the case of the photo-flo solution, should I want to get back the resistant quality of the surface, I can restore it to a certain extent by spraying on acrylic matte varnish. The result is never quite as good as the original, however, so I avoid as much as possible having to resort to this.

"Certain passages can get so exciting that it's a joy. Others I have to labor over before I'm satisfied. Sometimes, when I continue working over an area I have to take a chance and risk spoiling what's there.

"When the central area, the tree and the shrubbery under it, begins to shape up I can allow myself to feel that the painting as a whole is taking on some of the contrast and pattern of values that I've been working for all along.

"Getting into the architecture I feel that I don't want it to become too important. I want it to appear as though it were pretty much in the background and a very incidental part of the total.

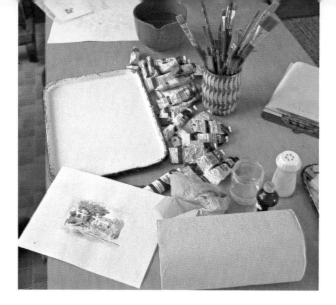

My palete is a white enamel butcher's tray onto which I squeeze my colors only as I need them.

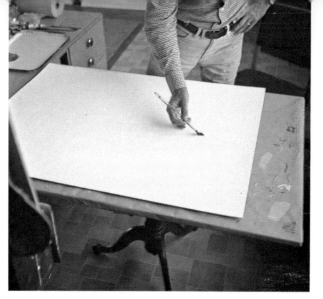

Contrary to the procedure usually followed in watercolor painting I work from dark to light.

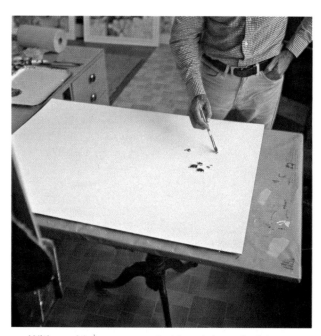

With a wide, square ended brush I can build color in mosaic-like patches.

The paint dries slowly on the non absorbing surface. An electric hair drier speeds drying.

As the painting develops I don't think so much of line and drawing as I do of values, masses and color relationships.

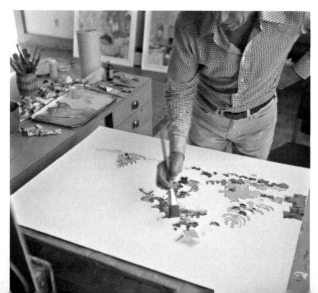

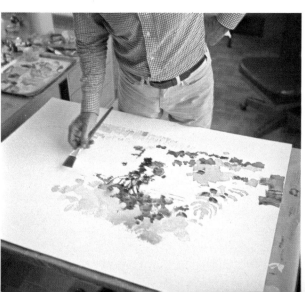

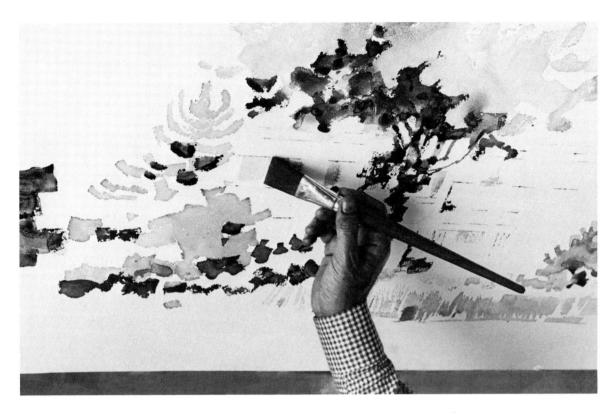

Here you can see how the gesso board resists the paint in much the way an oily surface resists water.

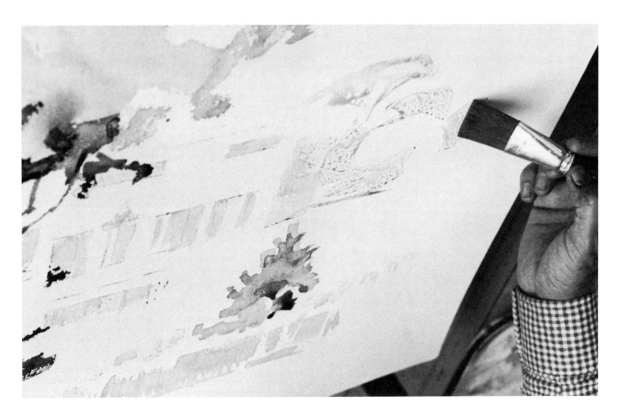

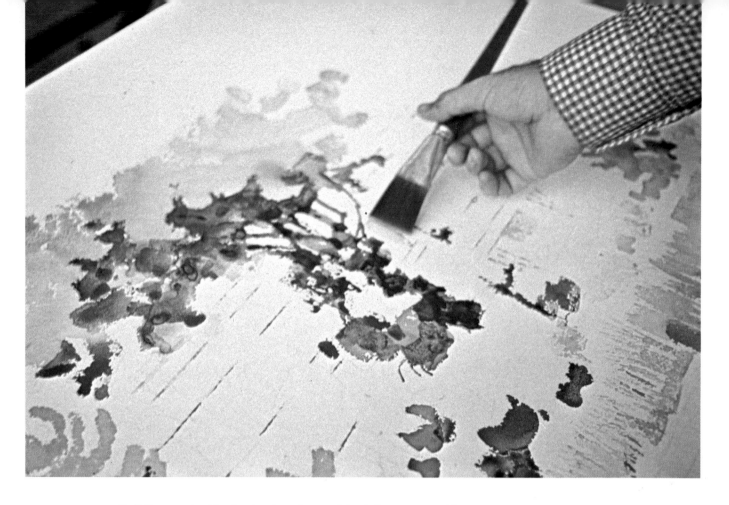

Building up the big dominating shape of the foliage mass with strong values and colors —

— to which the house remains a subordinate motif.

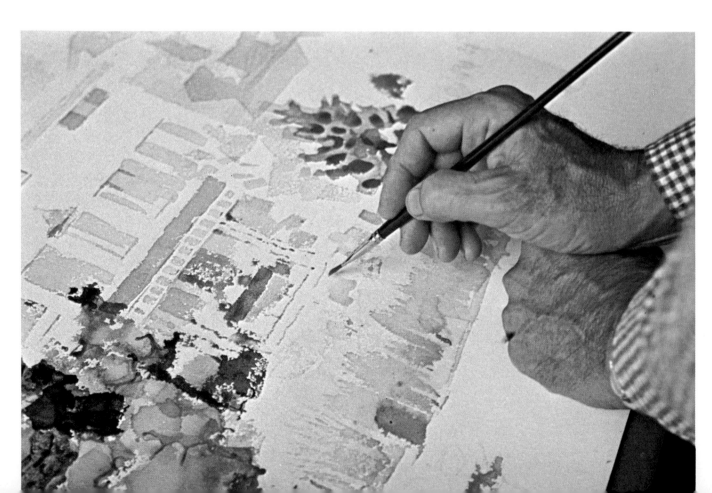

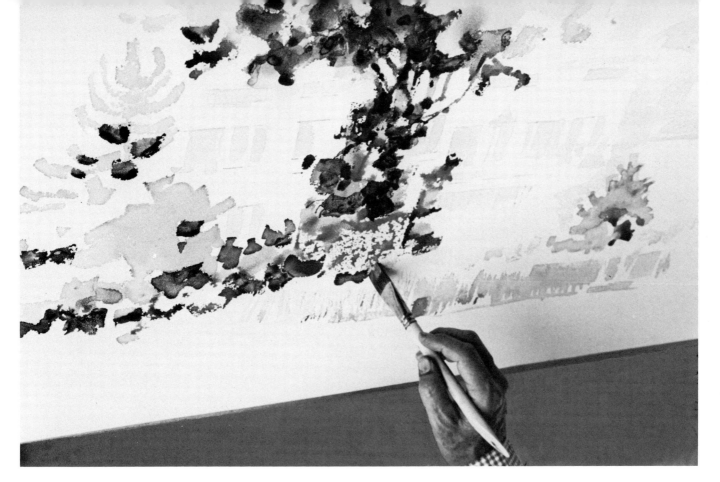

When I need to neutralize the resist character of the ground in a given area — that is, induce it to take paint in a normal way — I can apply a chemical solution (photo-flo) and allow it to dry.

The spot to which photo-flo has been applied will absorb paint in much the same way as an ordinary gesso ground.

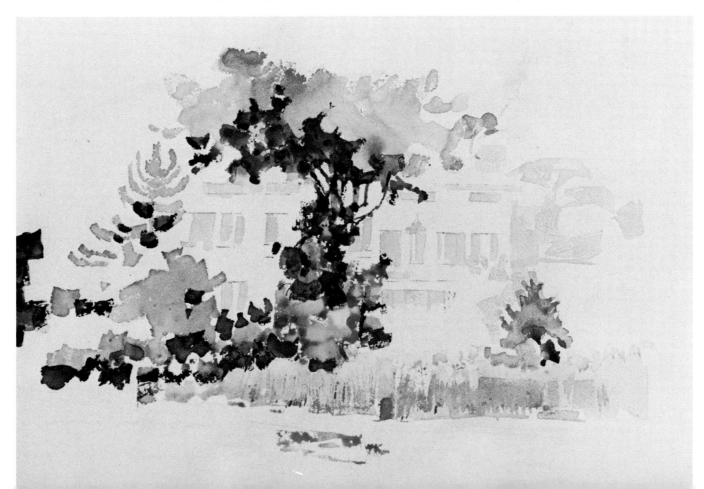

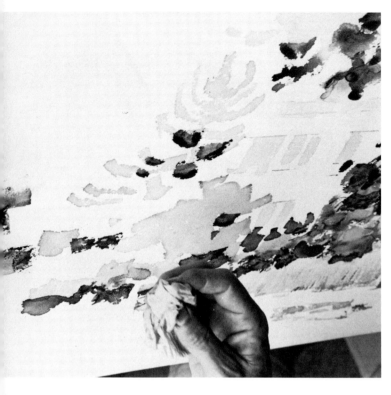

Blotting excess moisture with a piece of paper towel.

A smaller round brush for working into wet areas, blending and moving the paint around.

The square ended brush is versatile. It can be held flat for a wide patch of color, or edgewise to produce a narrow band.

The edges of each patch of color tend to become irregular and feathery as they dry.

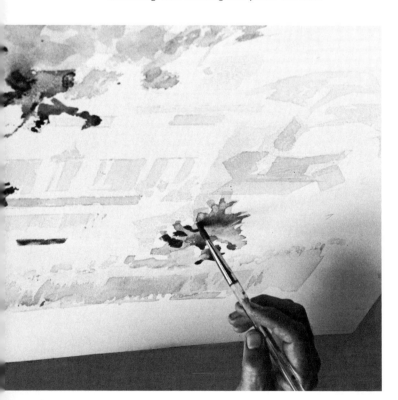

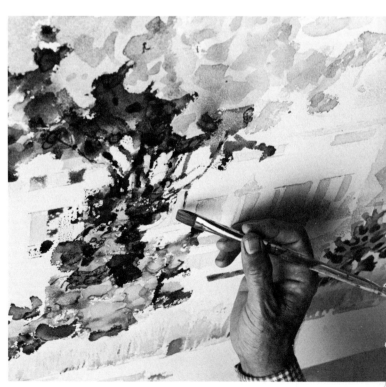

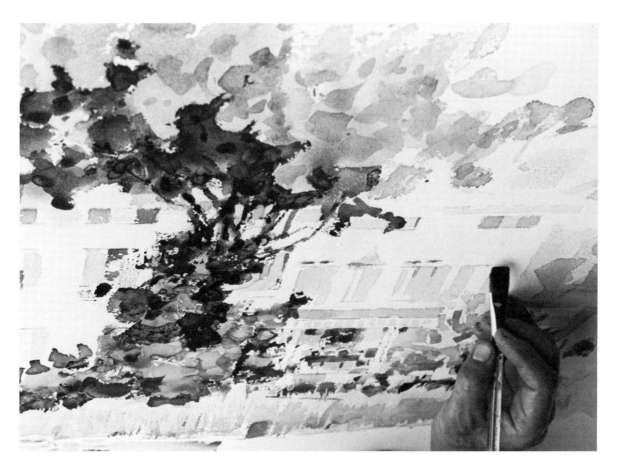

I paint with acrylics as I would with watercolor, using enough water to keep the pigment transparent.

"There's so much going on around the front porch, however, with its chairs and flower boxes and odds and ends, that I've decided to keep that colorful stretch from left to right across the picture. Its most important part is near the base of the tree. It makes a comfortable place in which to use bright spots of color that can be treated in an impressionistic way by letting all these things just melt together.

"The important thing about color, I think, is to give each area a chance to be dramatic in its own way. If too many colors of equal intensity are crowded next to each other the result can be chaotic. The dramatic quality of a color, or of two or more in any color relationship, is often best achieved by isolating, by surrounding the bright colors with darks or neutrals. I'm not always successful in getting this right away, but I keep working for it.

"Even in shadows, where the values are very dark, just a touch here and there of intense color — a bright ultramarine blue, for example — can pep things up and suggest a jewel-like quality.

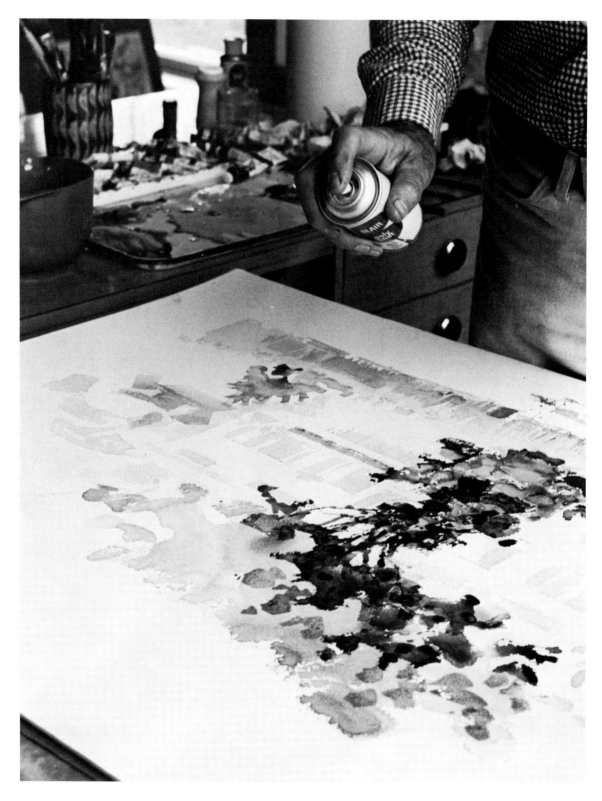

As the paint builds up, the surface tends to lose its resistant quality. However, this can be restored by spraying with acrylic matte varnish.

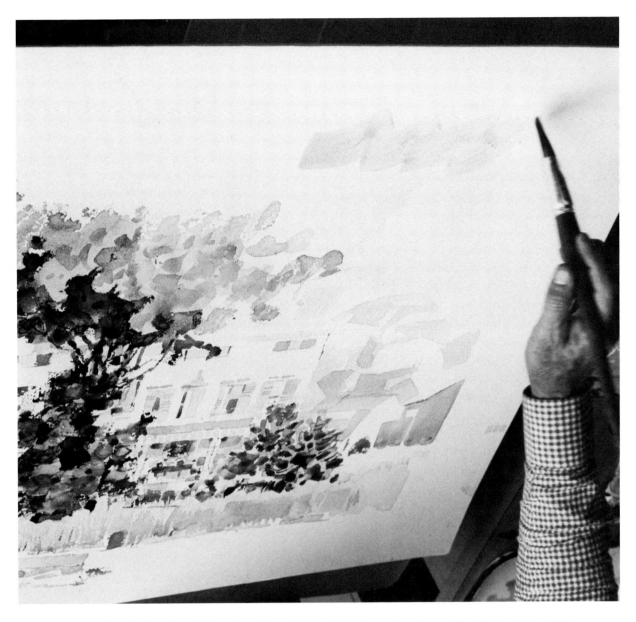

The pattern of the dark and middle values is established in the early stages. The light values of the sky are the last to go on.

"The treatment of the sky I've left to the end. I toyed around with the idea of introducing strong color here, perhaps a burst of almost overpowering blue, as though a patch of brilliant sky was shining through the clouds. But I turned that down as being too busy and decided instead that a simple relationship of two complimentary colors in a high key would be the answer — a pale gray violet against a very pale yellow.

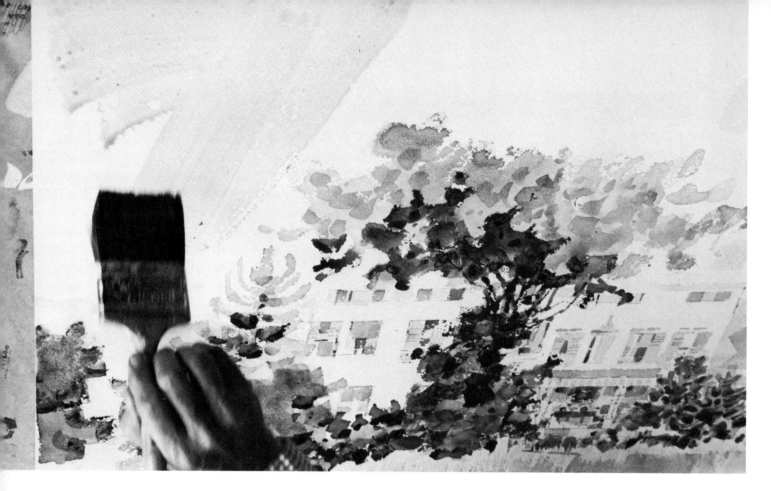

A wide flat brush for freely laying in the sky.

An unorthodox technique allows for a wide range of experimentation. Here I've laid paper towel over an area of wet paint which I then press with a textured material, in this case a fly swatter.

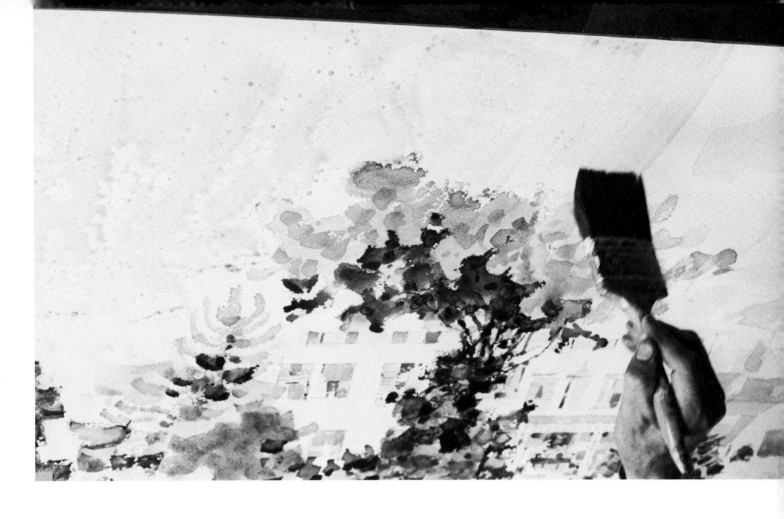

Individual brush srokes disappear as the resistant surface causes the pigment to
puddle and crawl.

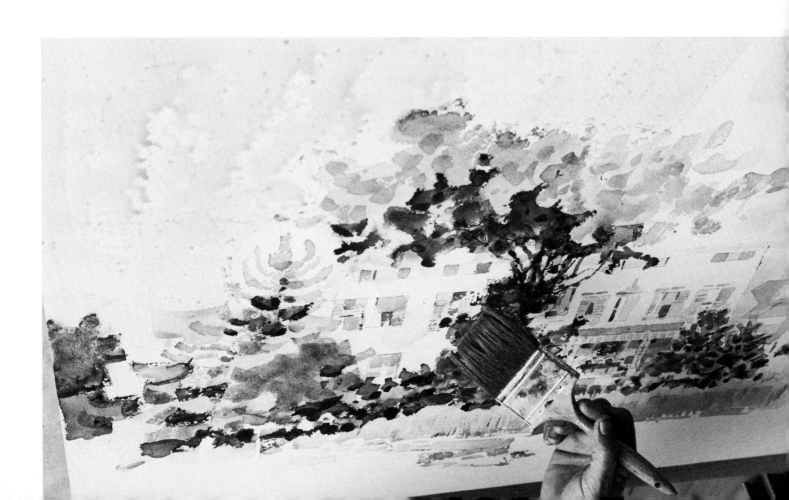

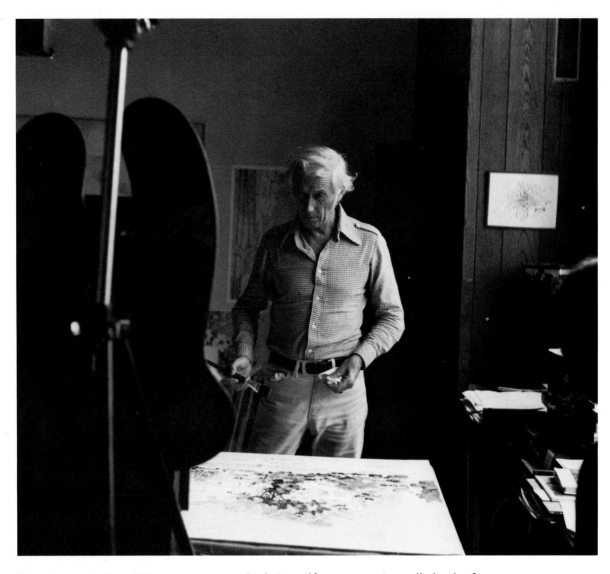

Time for evaluation. What areas are good; what need improvement or eliminating?

"There's a point at which I begin to refine all that I've done, watching carefully not to lose anything that I feel is good. At the same time something that seemed spontaneously right when I did it, I might now realize is not really as important as I thought. So then, if I'm going to be honest about it I'll make it right, take this out — good as it might be — and try something else. I do this repeatedly as I finish up, trying to be careful that there are no inconsistencies in the total effect.

"Finally, of course, there comes the time when I simply have to say that's it for what it's worth, and let it stand on its own merits. I have finished."

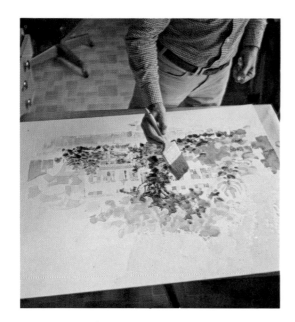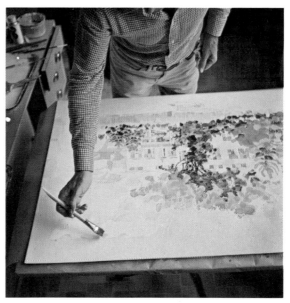

The sky is a complimentary scheme of light violet and pale yellow clouds.

The picture is finished.

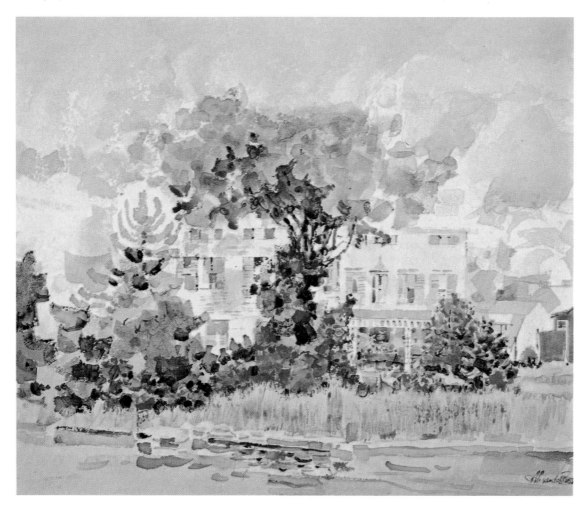